PROCESS

PROCESS

explorations of the work of

tim davies

david alston · iwan bala · susan daniel-mcelroy · tim davies · anne price-owen

seren

Seren is the book imprint of
Poetry Wales Press Ltd
Nolton Street, Bridgend, Wales
www.seren-books.com

The rights of the authors of this work have been asserted in
accordance with the Copyright, Designs and Patents Act, 1988

ISBN 1-85411-317-8

A CIP record for this title is available from the British Library

The publisher acknowledges the financial assistance
of the Arts Council of Wales

Printed in Plantin by Gwasg Gomer, Llandysul

Cover image: 'Tatters' (detail), 2002

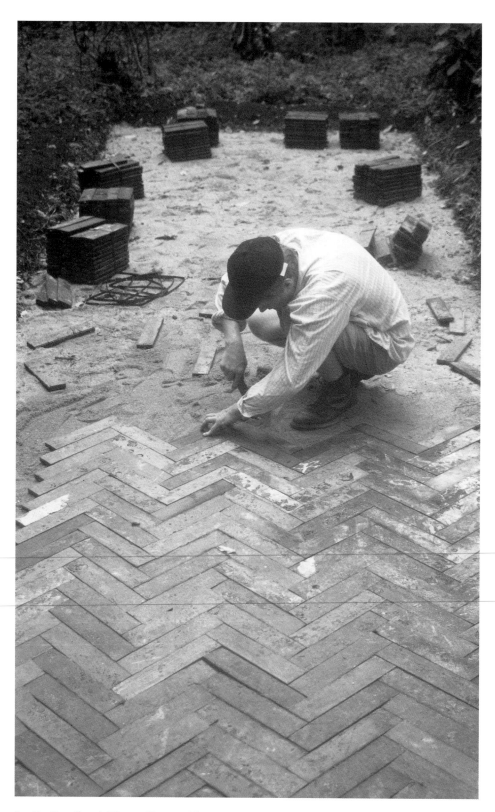

Installing **Llawr Fforestfach/Returned Parquet**, 1999, Poustinia Earth Art Park, Belize, Central America

YSBRYD SOLFACH

In 1997, when Tim Davies won the Ninth Mostyn Open prize worth £6,000, a visitor to the exhibition accidentally walked onto 'Capel Celyn' – the prizewinning sculpture – without noticing the ghostly grid of 5,000 wax cast nails placed delicately onto the floor. The poignant irony of this event seemed to reflect the meaning buried within the piece, for the visitor was relatively new to the area but quite keen on visual art. Davies, professional as ever, had nails in reserve for such an eventuality and quickly resolved the situation.

Tim Davies is one of only a few Welsh artists to totally embrace the formalist strategy and iconography of Modernism, converting it to his central purpose of engaging with political issues of personal importance, while making objects of pure visual beauty. His ability to structure his work in a Postmodernist context both enables and disables his cultural position. It is his drive to make work that has both artistic purity whilst at the same time delivering a political message, that places him outside of current mainstream practice. Much of British Postmodernist discourse is still very much focused on the ironic, the hip and the meaningless, and in this context of practice an artist who has both passion and integrity can come across as earnest and slightly eccentric.

Wales is a country where visual culture is not a priority. As a Welsh woman who left Wales after seventeen years of endeavour in the visual arts, I can say this with authority. Davies had to leave Wales for fifteen years to understand for himself how important his country is to him as a driving force for his work but, sadly, Wales is relatively bereft of opportunities for artists of Davies' calibre. Despite the Welsh Assembly, Cardiff has not yet demonstrated its interest in and support for the arts as have say, Glasgow and Edinburgh or Dublin. In Scotland, artists train and stay, determined to remain in their country. The Scottish Arts Council supports twenty-three visual arts organisations alone and one of these is Modern Institute. By comparison, Wales has only seven main centres for the visual arts and still no Museum of Contemporary Art in its capital. Wales has a growing reputation for not taking risks, not pushing for the best and for closing arts venues such as the Centre for Visual Arts in Cardiff.

In extreme contrast, Modern Institute – an organisation based in Glasgow – represents the brightest of younger Scottish artists on a world stage at international art fairs with some success. Such a small investment reaps reward as those artists are picked up by international institutions to be shown across the world. If artists in Wales are ever going to be part of that activity they have to engage with international exposure and they must be represented and supported for that to happen. It is not enough to be part of important cultural events such as the Venice Biennale, Welsh artists of quality, such as Tim Davies, must have appropriate support of quality on leaving their studies, just to get onto that world stage.

Visual art does not touch ordinary people, from a capitalist perspective, there is no money in it. The dominant culture in Wales is television. Through its programmes and advertisements made to reach the mass public, real money can be made. Advertising dominates our culture generally and is the context for the Postmodernist ironic discourse prevalent in the visual arts in Britain.

Tim Davies' journey has been steady and consistent since 'Black, black walls' was the National Eisteddfod Fine Art prizewinner at Neath in 1994. Within all his works made since, the double-take effect is evident and the viewer has only to reflect awhile to excavate the narrative buried in the work. It is his ability to carry out lengthy research to inform his ideas and then balance the form and content of his works that elevates his practice.

Unlike Richard Long, Davies is not working within the romantic British landscape tradition, yet each artist reveals a temporal dimension in his works: Long, through his lengthy walks over many days, and up to six hours taken to make one work within a museum; likewise, Davies makes many repetitive actions to complete a work. Both artists thus signifying human endurance and duration. Essentially, Davies has drawn down ideas to feed his approach from the formal beauty established by minimalists such as Carl André and Donald Judd and the work ethic expressed by Laurence Weiner as well as the personal epiphanies of such artists as Josef Beuys and Janis Kounellis. It is the clarity of Davies' voice and his attention to site, memory, history and process – all expressed through the concept or idea within the work – that carries it beyond mere emulation and makes it his own.

Lately Davies seems to be focusing more on the idea of an image that portrays both beauty and terror and in so doing, attempts to reclaim the image. Take 'Blue Funk' (2000) as an example. Explaining that he cannot look at a castle without reading it as an image of dominant power and terror, as part of *Locws 2000* Davies used blue light outside and within Swansea Castle to highlight it as an object to be looked at anew, outside of its current mythological status. Castles and Wales are romantically synonymous in the minds of most visitors and, having not understood the background of terror and subjugation of the Welsh, they happily wander its architecture and finally purchase an image or trinket. In their day, some castles were painted white – Conwy Castle in north Wales for example – with the effect of striking pure terror into the minds of those living near. Then, Conwy was to be approached by boat and the whiteness of the castle enhanced its visibility to those out at sea, signifying its power and control over the land upon which it stood. It is this combination of elegy and protest in the work of Tim Davies that will continue to be revelatory to those who understand the difference between seeing and knowing in a culturally specific context as well as a wider international frame.

Susan Daniel-McElroy

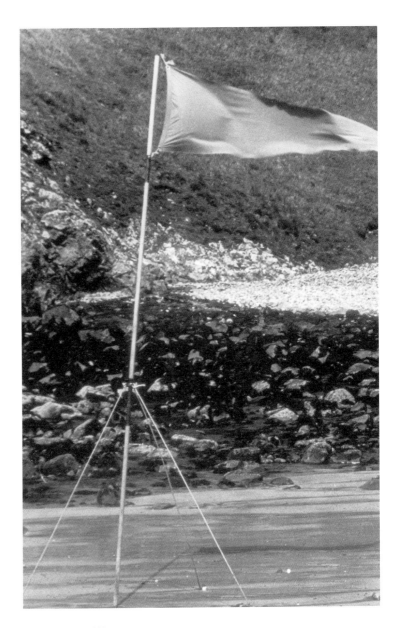

Flags over Solva, 1992

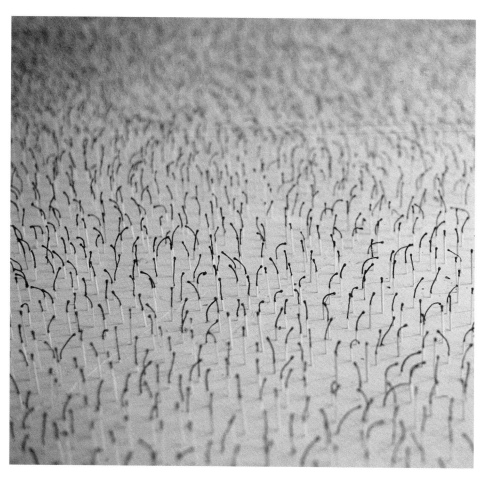

In Parenthesis (detail) 1994, at a derelict house, Tallinn, Estonia

WORKS OF ART

Some things in the world, some briefly present as material and moments within vaster time spans – a floor of meticulously spaced matches, lit, burnt, standing or curled in a room in Tallinn, Estonia; a ruined castle in Swansea illuminated for a number of nights with a saturating blue light; reclaimed parquet lying flat on the forest floor in Belize, where its mahogany wood once stood tall; some tern tail feathers adhering to the wall only by the sticky used sump oil in which they have been dipped and which runs down in lines that then appear drawn upwards by these quills, penning an environmental indictment. Some of the things Tim Davies has placed in the world – labour, materials, images, articulated thoughts, processes, references, signifiers and signified – his work.

Tim Davies' preoccupations perhaps all return to the incipient idea of what the work of art can be and his personal redefinition of this notion. He seemed to have had to create his own *tabula rasa* after a couple of 'false' starts (making music, painting) and only over the last decade with each piece providing its resolution after this re-thinking of the basic premises of what ideas, what materials, what expression, what preconceptions, what processes, what allowance for chance, what context, have works emerged. These works show both the greatest conceptual rigour and composition whilst allowing also for the inarticulate, the sensed, the intuited, the personal and the political to be manifested.

Davies brings the notions of work and art closer together than many artists. The cultural contradistinction at play in the separate ideas of 'work' and 'art' is as old as the bourgeoisification of both notions (that work was done by the labouring classes and art was consumed by the leisured classes as commodity) whence the uneasy conjunction of 'the work of art' and the Nineteenth Century's skirting of the issue by referring in 'cultured' French to the concept of *oeuvre* – work, without too much of the *ouvrier* – the worker.

Part of Davies' rethinking of how he was to make work has embraced the re-use of the raw materials for manufacture offered him by his native Wales, its history, industrialisation and exploitation. A land flooded to provide water for elsewhere, the harsh cold rural life of hill sheep-farming to provide blanket warmth for elsewhere, the peeling back of the land's surface to get easy access to coal creating the spoil there and fuel for elsewhere. All these have been ruminated upon by Davies, looking at the same time for personal expression and more universal significance. The last thing he has been interested in is agit prop – a sort of political didacticism, which would both diminish the politics and the context for his art. There were indications or leads for Davies in the dialogues between Beuys and Kounellis and in the Arte Povera movement. More immediately there was something to kick against in the minimalism of André or the at times precious and commercially credible practice of land art by Goldsworthy or Long. It is hard to envisage a Davies piece being dispatched to a gallery as a consignment and a set of instructions …(the sheet of instructions carefully annotated that it is not in itself a work of art!).

For this artist there remain decisions to be made *in situ*, but also installing a piece is part of the ritual of repetition and labour involved often in the industry

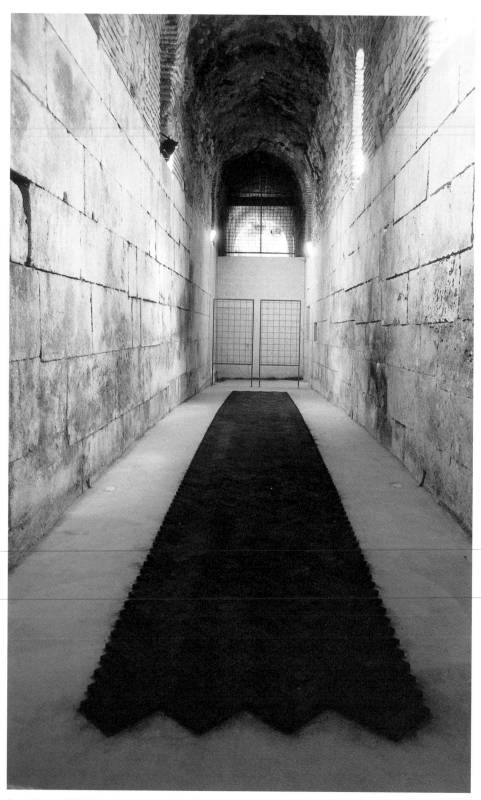

Burnt Parquet 1996, Dioklecijanovi podrumi, Split, Croatia

of producing the individual component parts of a piece, the wax cast nails ('Capel Celyn'), the charred parquet slats ('Burnt Parquet'), the drilled pieces of coal ('Black, black walls'). There is no doubt a fearsome moment in the inception of each work when thought, image, objects and the task come into resolved form. In many of his works, the questions of ideas, materials and execution parallel other cyclical processes in history, manufacture, and nature. Re-cycling, re-defining purpose as a result of this re-cycling, lies at the heart of a number of works. Added to this we find elemental intervention: water to aid rust and oxidisation, fire to reduce, refine, purify yet blacken. Process becomes in many instances key to many of the works, emerging as it does from the artist's reductive and yet charged thought processes combined with intuitive moves and often mind-numbing labour in the work's realisation.

In some recent pieces, as if to signal solidarity with basic manual tasks, hand tools in simple outline shape as they might appear in a trade prospectus present themselves in blank templates. Davies, on returning to work in Wales after a decade of training and working in art in England, literally sought to come to terms with the land of his fathers. Wales is as hi-tech as anywhere in the global village, but Davies, through the passing of his grandfather and in relation to his father, feels keenly the generational change from a society in west Wales where the hand fashioned or wrought still had its place in the scheme of things and where the concept of a material object not purely conceived in terms of consumerist phased obsolescence still had its value. In such a context hand tools perhaps passed from father to son, have a particular resonance carrying the value of the made-to-last. But there is now rupture. Few of us are nowadays apprenticed in any walk of life. We are told that 'brain' workers predominate over 'manual' workers. Within the area of art itself Davies has trained and teaches in a climate, which has jettisoned any last vestiges of 'apprenticeship' in favour of the overly conceptual and metropolitan. But for Davies a passed-on hammer, perhaps first held as a child when it felt just an ungainly weight and far from a useful tool, now is available to him latent with tasks redolent of all its past serviceable existence, at once useful and useless. Davies is affected by the mute world of stilled tools, their functions now superfluous or on the death of the owner, the tool's animating presence, the dumb uselessness of the once unquestionably useful.

The humble nail is another iconic object for Davies. Both archetypal and artisanal in its simplicity, a nail is mass produced to hold our fabric together but often outlasts the materials which it has held or lies discarded and unused, rustily surviving as an indicator of its unrealised potential or a vestige of something else that it bound but which has now disappeared. The surviving nail is a symbol of deconstruction having been the very nub of construction in the first place. It has rich metaphysical connotations – an instrument of the Passion, a signalling of the problematic – as in 'a bed of nails'. Davies' reductive process, rigorous analysis and perfectionism in execution clearly signals his commitment to the resonance of significance. He often presents the viewer with an arresting image of suspended, assembled components redefining floor and wall space, massing in our field of vision, intensely visual.

The organising principle is often a grid or system. This can underpin or generate works. But in Davies' use of the grid there are several differentiating features when set against more mathematical formulations. The first is perhaps the ideological driving principle of repetition derived in Davies' case not from theory or numerology, but out of empathy for the labour involving the mindless task or mechanical repetition fostered originally by hand work in industrial processes analysed in the Marxian notion of the division of labour and the disjunction of labour and work from product. At the same time the artist is drawn to the aesthetic of formal minimalism but will test its ability to field content as well as form. He is more drawn to musical as opposed to visual minimalists, composers building cumulative effects. Grid, process, repetition, accumulation, the building of an overall resonant field is paralleled in compositional procedures with links to aspects of Cage and more recently Reich and Glass. But further subversions of the grid must be noted in Davies' case. He introduces the aleatoric and unstable procedures of flame or heat, with an inherent loss of control and predictability within the strictures of his process. In not all instances is the grid a schema or underpinning, an organising principle. In at least one case – a recently developed series of the castles of Wales – the dense ruled biro interlocking grid creates image by obscuring the picture postcard images of the castles – a repressive interlocked network of the past rendered anodyne by our propensity to see these structures as picturesque heritage.

Davies' final twist on the minimalist aesthetic is to allow his pieces to be of variable size. He pursues responsiveness to locale and context, drawing meaning from siting and orchestrating given elements of a location. The forest floor pushing up new growth in the Belize 'Returned Parquet' is an affirmation of a renewed cycle carrying with it the aspiration that the interfaces of exploitation, value, commodity and exchange may be different over the next hundred years. The new growth equally implies the future archaeology of the work and its continued sense *in situ*. The charred parquet floor of 'Burnt Parquet' has had several manifestations in Split, Zagreb and in the National Museum and Gallery, Cardiff, each acquiring significance through context. The artist generalises about this work thus: "Using a disruption of an architectural detail to signify an inevitable violence that occurs through transference of power, 'Burnt Parquet' attempts to reclaim an ordering of structure and form after damage." This subtext allows for the various frames of reference to the culture and times of the work's presentation that environs will add. If anything its sombreness played off the dark baroque works that surrounded it in Cardiff setting off from 'The Jenkins Vase', the Roman altar turned in the Eighteenth Century into prized and costly garden furniture for an aristocratic seat, whilst from the walls dark portraits – articulations of standing and past power relations – surveyed the intervention. A work by Davies is never as a closed system but is always wilfully open and referential via the matter of its location.

A number of works by contrast have been made which explore language as resolved image making. Clearly some curators and writers have been drawn to Davies' work because of his espousal of notions of semiotics and the creation of meaning. Language and words have been used in works as another recovered raw material.

If language, Welsh or English, is physical cipher standing for image and creating meaning, Davies is drawn to destabilise it – make it cruder, have its words, which purport to carry meaning, become ambiguous again. An English-speaking viewer of 'Nage' will try perhaps in vain to see the word 'engage' before the patterning of the repeated Welsh 'No'. Indeed a work like 'Camera' is both a paradox in Davies' work and seminal. Rich visual images in words are presented in a disjointed, unsatisfying visual adjustment. Their presentation would appear to present both the artist's sense of their importance and personal significance to him and a measure of this frustration at finding a satisfying form for them – in stark contrast to other more purely visual resolutions of his work.

Yet the word works signal some of the primary and visceral impulses for this artist. 'Nage' stems from the rage felt at a loss through the death of the artist's grandfather. 'Dispossession' – one of a series of works made by suspension of objects in space – refers in its subtitle to "a study for lovers and strangers" (itself picked up in THEMOONDEADLOVERSANDSTRANGERS, a line of text from 'Camera'). The artist recalls the starting point for 'Dispossession' as a newspaper photograph of lovers from opposing sides in the Bosnian conflict, lying dead in no-man's land after trying to flee Sarajevo. The resultant piece is perhaps the most overtly histrionic and charged of Davies' work – and yet power and emotion, feeling is at the heart of all his works. The anguish and Beuysian personalised politics are not any the less for the apparent vigorous formalism of the work. In the repeated labour of creating the pieces and the chance effects created in the process of realisation, the works are inflected with hundreds if not thousands of individual touches – and the overall sense of fragility of the human condition, subjected as it is to forces that are of its own making as well as those outside its control, is conveyed again and again.

Tim Davies' work offers, in the late Twentieth Century and into the present, a further embodiment and resolution of what have appeared to be conflicting impulses of modern art, abstraction and empathy, form and expression. Often one has seemed inimical to the other or claims have been made for one tendency at the expense of the other, the abstract to signal for example the more cerebral, and the gestural to indicate more basic expression. But just as we approach a Mondrian painting and are put in the presence of the expression of the careful touch of the artist, or look at an early Stella abstraction and see as much of the presence of the artist as design, so Davies' formalism, exquisite and rigorous as it is, is no less when surveyed, testimony to ceaseless interventions of the artist, driven to controlled repetition because of what the field of these representations will ultimately unleash in the spectator – overwhelmed, engaged by the whole, drawn hopefully into the dialectics of each work and ultimately moved by the totality through the bit by bit labours of the work of this artist.

David Alston

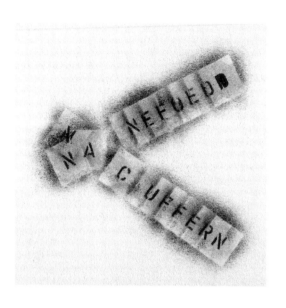

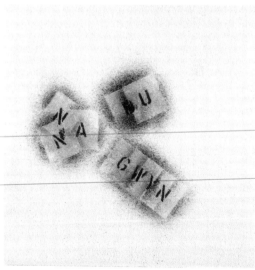

This page and opposite: Polarities 1,2 & 3 2001

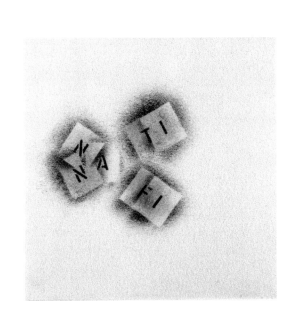

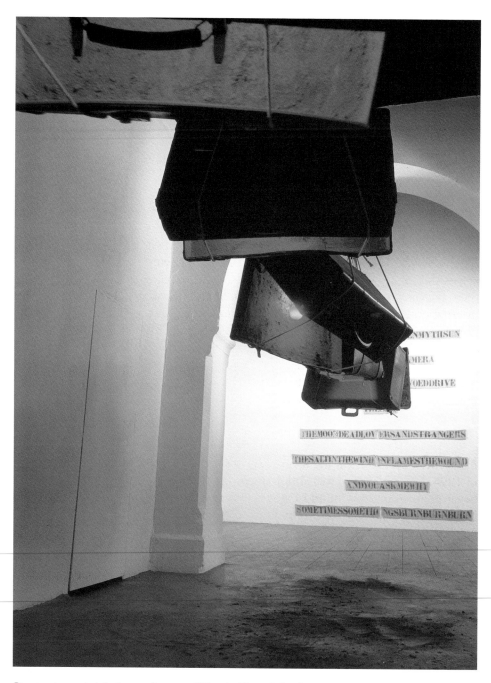

Dispossession – a study for lovers and strangers 1994 at the Mission Gallery, Swansea

PROCESSES OF DECOLONISATION

"Elusive truths are more easily caught in a small syntactical net."

It is a pleasure to be given the opportunity to write about the work of Tim Davies, since I have known him well, and been an advocate of his work, for some time. More importantly, it has allowed me to get some 'breakthrough' thoughts on his work which might have remained in the subconscious otherwise. I thank Tim and Seren for this opportunity. As an artist, I write this essay from the perspective of a fellow traveller, travelling down a rather rocky road. Being an artist is hard enough, being an artist perceived to be dealing with 'Welsh Issues' is harder still. Not so much in the making of the work (having a purpose must make it easier), but in the dissemination of that art outwards 'without prejudice'.

Tim Davies is an essential artist in Wales today, a suitable case for study as I keep discovering when writing or lecturing on contemporary Welsh art. Some artists display a qualitative standard, a degree of excellence that you can see in their art yet not explain. Their work would stand comparison with any on the international stage. Tim Davies' would. The only reason that it isn't placed securely there is because he lives and works in Wales. This is not simply because, as many of us complain, Welsh art is not taken seriously by narrow London-centric art critics, but that there is also a lack of conviction and of proper practical and critical support for visual artists within Wales itself. The publication of this book is therefore to be commended.

I

I first met Tim Davies at the Swansea Arts Workshop (now the Mission Gallery) in 1994. I walked in, he was sitting down, we were introduced and immediately began making plans. Tim and I would occasionally meet for a drink, in Cardiff, in Swansea, talking art, talking politics, getting heated, making plans. Trying to convince him of the integrity of certain things, understanding his own deep integrity. We agree on most things. Too late for the last train to Cardiff we go back to his house, I meet Stephanie his wife, stay the night. We work together, have 'meetings' with other Beca members: Ivor Davies, Peter Davies, Pete Telfer. I introduce him into The Artists' Project, he exhibits in Poland, I have bronchitis and can't go; he puts up my work in Lodz. A year later, I lay his 'Burnt Parquet' floor piece in the Museum of Modern Art, Zagreb. *Quid pro quo.* My wife Sophie and I trawl car boot sales and charity shops for the plain woollen blankets he uses as material. I learn of his background, his time in England, love of Solva, regret at being the first male in his family to 'lose' the Welsh language. I try to empathize but I am lucky, 'the language' was passed down to me. I try to explain what that means. I understand his deep commitment to Wales, and his even deeper commitment to his work. We talk of art and national identity, John Cowper Powys, Raymond Williams, Dylan Thomas, Peter Finnemore, the Eisteddfod and more. We are, one or the other of us, feeling 'down', we moan about the state of things, we raise each others spirits.

He and I take Robert C. Morgan, an American artist and critic (of Welsh ancestry), to Dylan's Boathouse in Laugharne. In 1998, I am one of the selectors at the Ninth Mostyn Open where Tim's 'Capel Celyn' wins, unanimously. I had also been selector at the Eisteddfod Arts and Crafts Exhibition in Bro Colwyn 1996, where he narrowly missed out on the Gold Medal. We have long telephone conversations, my wife is amused (or is she irritated?) listening to our talks, thinks we are both 'precious'. Like trainspotters or birdwatchers, we talk only of trains or birds. There is always a "how's the family" at the end though. He comes to my studio, gives sound advice and support. I go to his and hope I give sound advice and support.

That, much shortened, is the measure of our relationship. In the time that I have known Tim, I have got to know his work, even if my tendency is to see it from my own perspective. In this essay, I will try and elucidate my understanding, my perception of it and, just as importantly, of the space his work inhabits in the context of the wider world. I should admit from the beginning that what I am about to write doesn't follow the normal course of a 'catalogue essay' *per se*. It is rather a collection of reflections made on the basis of interpretation and on conversations with the artist over the years. The substance of these meditations is naturally biased towards that which I find most interesting in Davies' work and ideas, and in what I believe his work 'stands for' in its own particular milieu, its own 'place'. I will draw parallels with other, sometimes unlikely, artists' work, in other 'places', mostly to draw out contrasts that hopefully illuminate the thought processes and the finished works. I will also refer to events of recent Welsh history, which, I believe, deepen the connections of some pieces of work to a particular social landscape and environment. By doing so, I hope to place Davies' work, not only in its Welsh context but also in an international context which makes it apparent how best to appreciate it.

This essay fishes under the surface to bring up certain cultural reference points that locate and give meaning to Davies' work. They are sometimes researched, sometimes intuitive reactions which he himself describes as 'cultural intuition'. They form 'objective correlatives' that validate and extend his own 'subjective' imaging. They are also the 'ground' that gives his work a far reaching relevance and resonance, not limited to a reading of Welsh culture exclusively, but a more universal empathy and engagement apparent in work produced in locations such as Belize, Estonia and Croatia.

I I

In an essay on Davies' work, the critic Sue Hubbard says "Having abandoned painting as a student Tim Davies turned to materials that contained within them a physical resonance of lives spent in industrial and agricultural labour within his native Pembrokeshire. Using nails, coal, matches, feathers, woollen blankets and motor oil he creates *memento mori*, visual elegies ... This is work that mourns the passing of a culture and creates, not static formal memorials, but visual rituals of remembrance. The work grows out of the complex sociological ramifications of a society marginalised and in decline. Arte Povera here becomes the language of Welsh protest".[1]

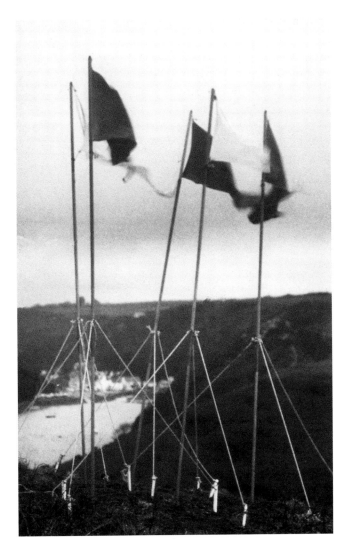

Flags over Solva 1992

Though I would argue with the use of Arte Povera in relationship to Davies' work, which does not share the aesthetic informality of that movement, a way of doing things that was non-predictive, there is certainly a valid case to be made of both elegy and protest.

I first encountered Tim Davies' work in the form of a grainy black and white postcard with a group of flags, triangular flags I recall, placed on a shoreline. This is a record of a piece of work called 'Flags over Solva'. Significantly, Solfach, or Solva, is situated in the centre of an axis of ancient western sea routes, by which the golden Age of Cambro-British Christianity communicated with the wider world as it then was. Whilst to the east, the pagan Saxons inexorably moved in. This was a millennium and a half ago. The erosion of land and culture has continued unabated. These flags seem like markers of the ever diminishing territory.

The curtains of coal in 'Black, black walls', 28,000 lumps, symbolic of the thousands of jobs lost in the mining industry, makes an artwork that is unambiguously direct. 'Matted' is a wonderfully austere, formally elegant piece of work. Feathers dipped in motor oil are glued to the surface of a white gallery wall in strict linear formation, and the oil allowed to run down the wall. These works are imbued with what one can only call a poetic sensibility, in particular that strand of Welsh poetry that is elegiac in its intent, but not sentimental and flowery; an *englyn* perhaps, a tradition whose eloquence thrives on the minimal use of words. 'Paran Chapel' consists simply of a faint outline drawing in pastel of a traditional chapel, drawn directly onto the gallery wall. Attached onto this, in an outward spiral, are a series of cast lead lizards, each identical. The drawing can easily be erased or worn away by time, it is drawn as a floating and weightless piece of architecture. The lizards, though existing in a different physical plane, seem to be overrunning the drawing. The ephemeral quality and sense of groundlessness that this work evokes is emphasised by the knowledge that each piece disappears when the exhibition comes down and has to be redone every time with a new drawing and placement of lizards. 'Burnt Wall' is made of twenty-five thousand matches stuck onto the wall and lit; they burn differently and leave irregular smoke traces. 'Solfach' features huge oars made of charred reclaimed wood hanging on thick ropes from the gallery ceiling. As you walk under and between them, they swing and strike each other gently, like boats floating in a harbour.

All these pieces have a formal beauty and organisation that is self-contained. By employing a straightforward meditative process, the viewer can discern a narrative message: the Thatcher closure of the coal mines; coastal pollution; the erosion of traditional ways of life and worship, (a form of worship, Methodism, that gave the Welsh, for a time, a confident notion of self identity, after centuries of insecurity and perceived insignificance); the purchasing of holiday homes in rural Wales and the resulting campaign of burning empty houses; the decline of the fishing industry in his mother's home village of Solva, the end of generations of tradition and livelihood. The artist says; "For me it's as much to do with economic ostentation in a deprived area, and of course cultural disturbances result. But the empty homes in the Winter off-season not only suggest ghost villages denuded of their cultural vibrancy, but also powerfully display in the face of the 'have-not' the arrogance and frivolity of the 'haves'."

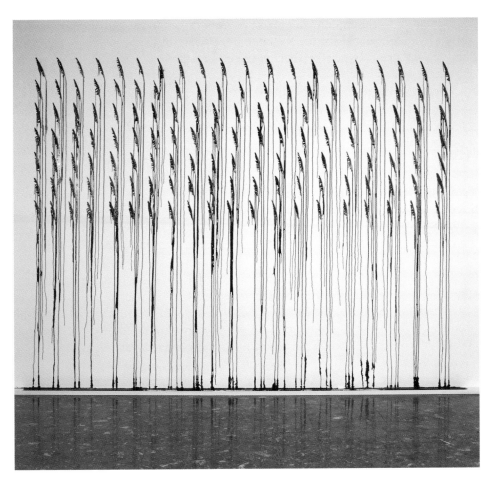

Matted 1996, at Howard Gardens Gallery, Cardiff

Davies is a natural minimalist, his house which he shares with Stephanie and son Siôn, the garden, the studio are carefully uncluttered. One might say he has a puritan minimalism: there is no unnecessary ornamentation anywhere. Outwardly, Davies' pieces epitomize the precept 'less is more' exemplified by Rothko and Brancusi before him. An economy in the work's form and elements. But unlike these artists his work refuses to be subsumed under a formalist closure; there is an inherent subtext that suggests an inward turning history, a sort of knowledge that can remain silent... like that which is contained in sites of specific memory to particular cultures. In Wales, Capel Celyn is such a site.

The events that transformed this rural location took place in the late 1950s and early 1960s, when a decision was made to flood the upland valley of the river Tryweryn and the little village of Capel Celyn near Bala, to provide water for Liverpool Corporation. Despite eight years of protest by the inhabitants of Capel Celyn and their many supporters (Eamon De Valera included), the plan to evacuate the village, level the buildings; the school, houses, post office, cemetery and chapel, and flood the valley went ahead. Every Member of Parliament in Wales voted against the decision, to no avail. The affair highlighted the cavalier way in which Welsh land, people and concerns could so easily be disregarded for the needs of the (English) 'common good'.

The French historian, Pierre Nora has defined a concept that he calls *lieux de memoire*, where specific sites, man-made or natural, scenes of historic events, can become symbolic places within colonised nations, both as points of reference for the colonisers, monuments and civic buildings, or sites of significance to the colonised, places of resistance, of victory, and more poetically, of defeat. In the make-up of any nation or community, there are these important physical and conceptual sites that contain the essence of a collective memory. Nora[2] associates the role played by memory with a 'symbolic typology', in archaeological terms, a 'type site', and identifies the sites where memory resides as *lieux de memoire*, (a physical and conceptual site, the realm of memory). This term can apply to "any significant entity, whether material or non-material in nature, which, by dint of human will or the work of time, has become a symbolic element of the memorial heritage of any community". Nora makes a distinction between memory and history, claiming that "memory is life" whereas "history is the reconstruction of what is no longer". Memory is subject to remembering and forgetting, it is vulnerable to appropriation and manipulation. It can lie dormant for long periods only to be reawakened suddenly. The *lieux de memoire*, the symbolic and functional sites, are the products of interaction between memory and history. These sites display the exciting quality of being able to change, to resurrect old meanings and generate new ones, along the way establishing unpredictable connections. Intervention with, and interpretation of these sites by creative artists, whether painters or poets, film makers or theorists is a prime catalyst in their regeneration.

Davies is well aware of this, and in choosing Capel Celyn as a subject, he not only continued a tradition made by poets, writers and latterly, visual artists, but also created a parallel 'site' in its own right. 'Capel Celyn', the floor installation, is not just a diagram/illustration referring you to the real location, the site of the

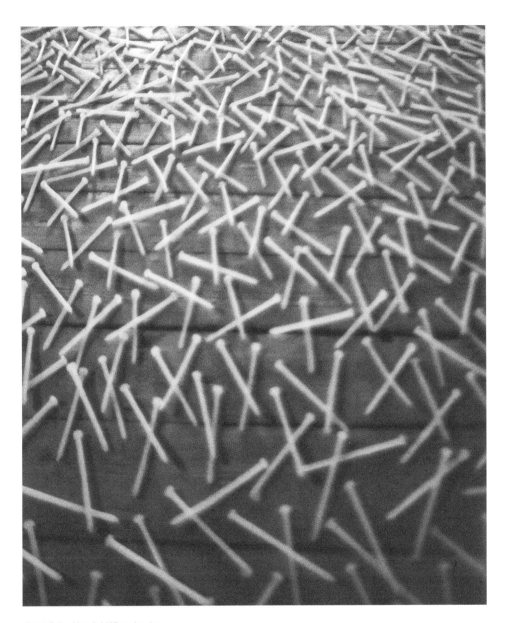

Capel Celyn (detail) 1997 studio shot

reservoir, which is also the site of an historic memory and of political and symbolic significance, but becomes itself such a site when viewed on the gallery floor. In 'Capel Celyn' the artist utilized a single five inch nail retrieved from the reservoir when the water level was low because of drought. This single nail was replicated 5,000 times in white wax and laid like a spectral carpet on the gallery floor. Mute, ghostly, a reminder of the silence of the lake, the silence of a community and perhaps, nails in the coffin of Wales' core identity. Nobody has pointed out, what a farmer would notice immediately, that a wax nail is the most useless of things. Does this allude to the uselessness of protest? Or to the perceived uselessness of lives spent in a Welsh speaking world, scratching a living from a form of subsistence farming?

An exhibition at the Spacex Gallery in Exeter in 1997 featured 'Capel Celyn' and took that work's name as the title of the show. The text and publication that supported it contained a short socio-historic treatise (by Alex Farquharson) outlining an account of the drowning, and likening the political impact it had in Wales to the galvanising effect of Bloody Sunday in Ireland. Farquharson makes the interesting point that, unlike the (Postmodern) young artists of London and elsewhere who have to create new images in "an artworld and urban environment saturated with images of itself, an artist living and working in south Wales is faced with the reverse predicament of an absence of representation". An artist like Davies then has to find 'forms and signifiers' to deal with his environment, events and memory, from scratch. This, Farquharson concludes, is a very un-Postmodern role. It is however, a role well documented and experienced by artists in the Third World, in the former Eastern block, in areas that are in the process of decolonisation in one form or another. These artists work not only with the absence of representation, but with a colonialist representation foisted onto them. They have to create anew, but also subvert and finally, displace the colonialist representation.

Protest and elegy characterises the ethos of the work. I believe that Davies' choice of subject matter (though not done as a 'ticking off the list' of worthy causes), taps into a wellspring of recent myth-making in Wales. Both 'Capel Celyn' and the 'Alphabeca' works cannot avoid connections to the political actions that began in the 1960s in Wales. The event of the flooding of Capel Celyn village stands alongside the historic radio broadcast made by Saunders Lewis to the Welsh-speaking nation. 'Tynged yr Iaith' (the Fate of the Language) in 1963 was a clarion call, warning that the Welsh language was in a state of terminal decline. This speech galvanized a whole generation of young people to an awareness of the dire plight of Welsh-language culture, and moved them to revolutionary political action, a kind of anti-colonial insurrection the like of which had not been seen on mainland Britain. Through the founding of Cymdeithas yr Iaith Gymraeg (the Welsh Language Society), whose emblem is the dragon's tongue, they worked for a rejuvenation of their culture and their country. As in the *Mabinogi* story of Branwen, the survivors of a great war in Ireland spent an idyllic time on an enchanted island, forgetful of reality and the calamities that had befallen them, but time came to 'wake up'.

A similar awakening took place in the visual arts in the 1970s, with the

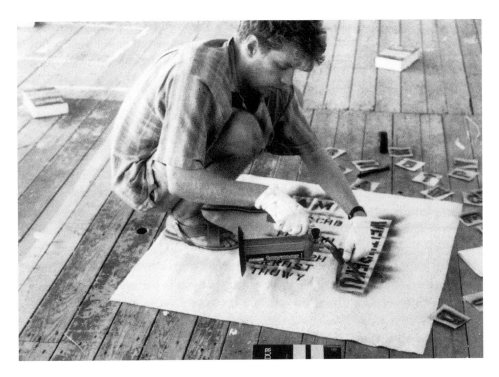

Alphabeca Performance, Beca Group, National Eisteddfod, Abergele, 1995

formation of Beca, a group that took its name from nineteenth-century insur-rectionists. It was as a response to an invitation to join Beca that Davies began the series of works invoking the alphabet of the Welsh language. Beca's impor-tance, its drive to regain control of our own representations, is still largely unrecognized. It was the instigating force in the politicization of Welsh art, and one that re-invented international trends and methodologies to highlight specific concerns in Wales. Drawing from sources as diverse as Arte Povera, Fluxus and, particularly in the case of Ivor Davies, Surrealism, the Paris *avant garde* and Destruction in Art, Beca made collaborative pieces and events as well as indi-vidual works that dealt with such issues as Tryweryn, loss of language, holiday homes, appropriating elements like the love spoon and the map of Wales for the purposes of a commentary of protest. Beca's driving force, the artist and teacher Paul Davies died aged forty-six in 1993, but left, as the title of a memorial exhi-bition has it, "a continuing presence".

'Alphabeca' and related works 'Nage' (involving the repetitious burning of the Welsh word *nage*, which translates as 'no' or 'it is not', onto a stretched woollen blanket) engage directly with language, specifically here, the Welsh lan-guage. They are not about calligraphy as design, nor about clever word play, conundrums or thinly disguised 'jokes'. Nor are they intellectual text pieces: they are heartfelt, anguished if restrained, attempts to clutch at a language that only one generation back was the mother tongue of Tim Davies' family. Tim Davies shares with his namesakes in Beca, Paul Davies and his brother Peter, that same acute sense of dispossession, of being born into a family that had only recently 'lost' the language. The Welsh words, consonants are 'seared' into the blanket, as though by doing this, they can also be seared into the memory.

The use of words in art is hardly an innovation and it would be wrong to conclude that words are merely another medium, they have a history in visual art. One immediately thinks, close to home, of David Jones' idiosyncratic text pieces, or his mentor Eric Gill. A wider view might encompass American artists of the fifties onwards: Ed Ruscha, Jasper Johns and later conceptual artists who were preoccupied with knowledge and language. One might also think of Raymond Williams' writing, in particular his exploration of 'key words' within social, artistic and political discourse.[3] Davies is also influenced by concrete poetry, where words on a page take on formal arrangements, contradicting the proposal that art and literature were mutually distinct, painting extending through space, poetry through time. In Dylan Thomas' 'Vision and Prayer', from the *Collected Poems 1934-1952*,[4] the page can be seen almost as a pictorial space and a visual rhythm is woven from the layout of the text. The words utilized by Davies in his pieces are precise, they are not titles written on the work, nor glib one-liners but words that, like all his work, carry a host of references and allu-sions, and yet equally exist as formalist marks on a canvas.

To devise and make works that carry these connotations and references, that carry an anterior history of their own, is mentally demanding (it is not work that can be made by hand and eye alone, or intuitively). All the works require consid-erable thought, periods of trial and experimentation, failure and reconsideration. They are not gut reactions and therefore are distanced from the actualities, the

Nage (detail) 1994

events and situations referred to. In this way they avoid being mere illustrations and become self-contained equivalents of those subjects.

'Llawr Fforestfach/Returned Parquet' involved shipping mahogany parquet from a reclamation yard in the Fforestfach area of Swansea to the rain forest of Belize from whence it came. Originally the wood was cut down by colonial slaves, but in this piece it is returned to the forest floor, quite literally it is laid down in a pathway amongst the trees. The gradual encroachment of the jungle onto the pristine parquet becomes part of the work as termites eat it and plants push up through the area of rain forest cleared by the artist to lay it. He expects it to eventually disappear in its true 'reclamation'. Thought, worry, discovery, inspiration, execution, statement... placed out in the world, left there: an exquisite 'closure'.

One series of works deploys the humble matchstick as material. Matches are adhered to the surface of a wall, *en masse*, or stuck like debranched trees on the floor, then set alight. I read recently how Soviet officers, during the Second World War, were prone to use euphemisms. "How many matches were burnt?" was a typical request for casualty estimates. Bearing this in mind, one can imagine the match sticks as representations of wasted people, or in Davies' own description, a "burnt field", a landscape both topographic and cultural, laid waste by political upheaval. In the statement that accompanied 'In Parenthesis', made in Tallinn, Estonia, in 1992 and 'Burnt Parquet', made in Zagreb and Split, Croatia in 1996 he says: "A thousand matchsticks stuck erect on a floor and burnt. A pathway leads through this fragile burnt field. It makes reference to a transitional space between one political ideology and another, using a disruption of an architectural language to signify an inevitable violence that occurs through a transference of power. Burnt parquet floor (that by its very nature defines a sense of space through its pattern and structure) attempts to reclaim this ordering of structure and form after damage".[5]

As this statement makes clear, the impetus of such works as these is universal in that it deals with political change, violence and shifts of power. Again, we can return to an historic occurrence in Welsh protest that might be referenced through these works of 'burning'. In 1936, Saunders Lewis, along with another two well-known figures of the Welsh Establishment, Lewis Valentine and D.J. Williams set fire to a bombing school being built by the British Government at Penyberth on the Lleyn peninsula, despite local and national opposition. They reported their 'crime' at a nearby police station, and there followed a celebrated and protracted court case, which was eventually moved to London. The three were imprisoned for a nine month stretch and Lewis lost his position at the University of Wales. This act of courage has a significant place in the annals of Welsh resistance and protest, and in a sense, these 'non-violent' yet symbolic acts, of which this was the first, are reflected in the ordered symmetry, the lack of chaos, that exists in Davies' work despite the use of fire. The act of burning is a controlled act, a responsible act.

Inherent in many works is a sense of absence and presence. Objects are highlighted as 'shadows' of themselves, or more correctly; traces. Nails, for example, repetitions cast in wax or leaving traces on singed blankets. The absent nails (or nail, as one single nail made all the marks, in the same way that one nail

engendered the 5,000 cast progeny) might denote the absence of a people, and with them, of a culture, a way of life. In other works hammers leave traces, which are partly explained by the experience of working in Swansea gaol. The absence of a hammer is indicated by its painted 'shadow' on the wall where all the tools should hang at the end of the working day... absence denoting theft and possible (violent) misuse. Where repetition as a formal device in the art world has become an end in itself, here it serves to emphasize the terse, methodical (not to say Methodistic) economy of visual metaphor and of material. As in a sermon, a Methodist preacher would take one single line from the Bible and extract all its meanings, morals and intellectual and emotional content. Dissect it, deconstruct and elucidate it, bringing forth hidden interpretive meanings, construct a whole Christian theology from a single line amongst thousands.

At some crucial juncture in Davies' working process there is a dichotomy, a branching into two streams, the one that is loaded with 'meaning' in a narrative sense, the other whose meanings are invested in the language of art itself. The second stream, which I have not yet addressed in this essay, is formally self-referential, it is about making art, making objects that exist for and about themselves alone. This duality has been, for the past century, a cause of stress in art, a bifurcation of purpose that has caused heated argument and engendered the most challenging of artworks and movements. It lies at the heart of Davies' work, a dilemma perhaps, between his avowed concern for the well-being of his own square mile, his role as remembrancer, and of his natural inclination towards sculptural integrity, formal aesthetics, a classical sense of order, materiality, space.

But it would be misleading to believe that art can at any time be without content. Despite the artist's best intention, content insinuates itself into the work. 'All art is political' is a commonly used, yet often overlooked statement. It can be shown, however, that formalist abstraction, in particular the American version of it, has as much subliminal, 'national' content as any other art, perhaps more so.

Barnett Newman is the arch-American abstract painter, the most pure of painterly minimalists, whose art is ostensibly content-less or at least directed as a critique of art itself. His most famous painting; 'Who's Afraid of Red Yellow and Blue' is a critique of Mondrian (and was itself parodied by the black British artist, Frank Bowling in his 1969, 'Who's Afraid of Barney Newman'). In an interview with David Sylvester in 1965 Newman said that his paintings "give a man a sense of place; that he knows he's there, so he's aware of himself. In that sense he relates to me when I made the painting because in that sense I was there". There is an overwhelming sense of confident male territorial machismo about a statement like that, one that immediately enters you into a particular time, place and sensibility. The paintings also share that sense and point to the fact that Newman and others at that time held a consciously 'national' agenda, as American artists. His "canvases encourage us to see far beyond their undeniable thingness, and far beyond art, to the place where 'absolute emotions' sustain a politics of the self in absolutist American style".[6]

III

In 1999, I compiled *Certain Welsh Artists*,[7] a collection of essays by several artists and writers on art, 'certain' being a play on the word's two meanings. It was sub-titled 'Custodial Aesthetics in Contemporary Welsh Art'. The introductory essay, which was sent out to all the contributors as a means of eliciting responses, suggested that 'certain' Welsh artists, who were 'certain' of their Welshness used a 'custodial aesthetic' to bring cultural memory into the make-up of their work. 'Capel Celyn' by Tim Davies was central to this view and indeed was featured on the cover.

'Capel Celyn' is a work that is against forgetting, it contains memory, and I would postulate, is a prime example of custodial aesthetics at work. It does this by making us think again about that piece of history, that site of memory that is Capel Celyn, bringing it alive in a new way. Matter and subject transformed into something new.

'Custodial aesthetics' is an invented term for a phenomena within a wider, global, cultural debate, and therefore not restrictive at all. It could be seen as being more truly universal than the work of a small elite of 'chosen representatives' of Western art's market-led dominance. The term does not apply simply to the 'intent' behind individual works, nor of an artist's intent necessarily, but refers to that particular artist's work and how it operates within a cultural construct, an imagined community, and in the context of a wider formation of writers and artists, who keep on inventing and reinventing that community and unearthing its cultural memory.

Substitute artist for poet in the following quotation from writer Robert Minhinnick: "Poets are often seduced by the melancholic pleasures of cultural alienation. This fastidiousness means their work is easy to dismiss as a cry from the sidelines of life."[8] Cries from the sidelines of life have a way of being more universal than those from the mainstream, though the latter, through critical attention and marketing strategies, are given the appearance of greater relevance and significance. This is, of course, a ploy to maintain the *status quo* of the hierarchical structures of power. I have a feeling also, that if we were to further analyse this concept of the 'fear of being sidelined'; not only would we find that it has a certain legitimacy in an art world that is centralized to the metropolitan capitals of the West, but that it is also, more significantly, a symptom of the colonized mentality. "A conspicuous feature of the Welsh condition in the Twentieth Century has been that sociological phenomenon known as 'culture shame', a condition that explains a lot of things in Wales."[9]

The Senegalese artist Moustapha Dime says, "Even though I was born in Louga, I consider myself as a universal being. If I didn't succeed in keeping my own roots, I could never be universal because it's on that basis that I can become universal, on the basis of my own roots. Because that's how I have become what I am. The humanity that I am in the process of living today is born in my own roots".[10] Dime may never become world famous, but somehow, there is a greater truth to his position than in that of many much-heralded 'international artists'. Davies makes a similar statement when he says that if he wasn't

Welsh, he couldn't be sure of what he would do in his art. In this there is the sense that being Welsh, with its particular sensibility, informs his work.

This statement is a risky one to make in today's art world. It smacks of 'nationalism', a contentious word not far removed from 'racism' as we have seen in recent press and political reactions to those Welsh people who protest about the loss of their culture in the rural heartlands of Wales. The preferred terminology, 'cultural specificity' is one of those keywords of contemporary critique, revealing that distaste for any terminology that includes the prefix 'national'. There is a fear amongst critics, writers and curators to accept nationality as being a valid factor in the production of art. In contrast, the Spanish critic José Jimenez can talk easily of 'nationalities' within Spain as a positive thing: "memory and plurality are now expressed through the plurality of the different nationalities making up Spain", when talking of new Spanish sculpture: "Spain is a country made up of countries; Castile, Catalonia, the Basque Country, Andalusia, Galicia... memory has become intensely plural; different sensibilities connect with the various cultural traditions that are alive in the historical background of today's Spain. The span of the journey is also open and plural."[11]

Britain, in contrast, is far more centralized, London exerting an overbearing gravitational influence. Whilst sculpture in Spain can celebrate the plurality of its make-up, not only its appropriation of influence from the outside but from within (and we could add Chillida, Oteiza, Gonzàlez to that list), British art has to eschew the regional idioms in order to escape the sobriquet 'provincial'. Hence the reluctance of artists to foreground such concerns. It cannot be admitted that there are still differences amongst the national groupings of Britain. Equally, it seems beyond the English to accept that 'nationalism' features in the promotion of 'Young British Artists' for example.

This structure of thought is partly due to the ever present ideas of 'Union' in Britain, where the dominant characteristics of Englishness have been grafted onto Britishness, comfortably obfuscating the fact that Britain (Prydein) was originally a Welsh linguistic and conceptual territory, that for some time it has incorporated both Scottish and Irish indigenous nationalities as well as Welsh, and that today it has within itself a host of immigrant micro-nationalities. The concept of 'melting pot' does not work here, if indeed it works anywhere, each 'nationality' must seek its voice, but the 'Union' decides to try and ignore that by projecting a 'one voice, one nation' concept of British art.

A national feeling is not necessarily synonymous with nationalism, and each and every nationalist tendency is not inherently evil, as seems to be the consensus amongst the metropolitan chattering classes. Nation does not equate with State since many nations are stateless, and many states have no national coherence nor territorial rights. Native Americans for example, consider their cause a nationalist one. However, they prove that nationhood need not necessarily be seen according to the European notions of sovereignty, territorial or hierarchical. National sovereignty can equally be vested in tribal memory, humour, tradition, practice and survival.

Davies' work holds up a mirror to the processes of nationalism and post colonialism, in particular the decolonisation that becomes necessary in that

process. It also mirrors the paradigm of the subaltern culture[12]; its 'meanings' (memory, humour, practice and survival) hidden from view under the outward semblance of the colonialist appearance. An appearance partly forced on it, partly adopted as a protective device. The colonized mindset that mimics the appearance of its dominant 'conqueror', whilst secretly maintaining its inner identity, hiding its true 'meaning'.

Decolonisation means actually getting rid of our colonised mentality, waking up to the hegemony, as Gramsci calls it, of attitudes that have been assimilated from the colonialist perspective and tend to ossify. A process occurs where there is a normalization of the abnormal so that it comes to be seen as natural, inevitable and immutable. Decolonisation means that we must speak of things that inbred assumptions and the fear of offending tells us should not be spoken of. In the view of Franz Fanon this process requires violence to make it real; Wales is not a country of violence, but it could be argued that a symbolic violence crops up in the visual arts of the past twenty, thirty years. In the work of Beca, a quite palpable 'violence' existed in the paintings and constructions of Paul Davies that was shocking to an audience in the 1970s. Tim Davies' use of a process of scorching materials; hundreds of burning matches, singed blankets with a scarification of lettering made with a blow torch and stencil, blackened blocks of parquet flooring relayed onto polished parquet within the National Museum of Wales, huge hanging charred wooden oars (is the lifeboat burnt and sunk?) holds echoes of this violence. More recent work involves cutting out images or scoring across them.

Issue-based art, the raising of content to the level of form, of content over form, can be seen to be problematic in the currency of Modernism, the issue overburdening the formal aspects of the work, toppling it over. Always that old duality of the creative impulse causing conflict: Form and Content. Davies has avoided this, maintaining a balancing act with form and content so that his work can operate successfully on two levels, a "complex synthesis of materials, form and content" as Martin Barlow wrote[13]. For those who wish content to take precedence, or form with no content, this can be annoying. Of course there is content and there is content. We are accustomed in the West to be subjected to the artists' autobiographical, confessional content. That the content should involve cultural specificity only adds to its relevance or irrelevance, depending on your persuasion.

IV

Rosalind Krauss in the late seventies, argued that sculpture had passed into the 'open' and contingent space of the installation, incorporating its surroundings, be it the gallery or external site, as a source of expanding meaning. The boundaries between architecture, design and art had finally been disposed of, revealing sculptural space to be grounded not necessarily in the production of things but between things.

Tim Davies is an essential artist in Wales in that he fits into the history that has so far been recorded up until 1960. Should that history ever be updated, it

would be impossible to imagine that Davies would not feature centrally in the period 1990 until today. Not only is he 'imaging' the nation for and in the manner of today's world, but his work spans over and connects work produced in Wales, and about Wales, with work produced internationally in several corresponding and interesting areas. Immersed as the work is in the aesthetics of certain strands of sculptural activity, its context links it to the statements made by post-colonial practice in the work of artists in Brazil, Croatia, Catalonia... or of the so called 'in-between' artists whose background is in Africa, Asia or the Caribbean, but who were born or live in Britain or the United States.

Surprisingly, closer to home, there are strong comparisons between Davies and the 1980s and 90s generation of British sculptors whose work has been construed as at least a partial recuperation of an indigenous ethnic Britishness. More accurately perhaps we should say, of Englishness propped up by the English appropriation of Britishness based on Stonehenge, stone circles etc. Following from the more international and cosmopolitan sculpture of Anthony Caro in the 1960s, came artists like Tony Cragg, Richard Long, Gilbert and George, Anthony Gormley, some of them students of Caro at St Martin's School of Art. In an England which is no longer the centre of a great empire, an England forced to see itself as a minor player on the world stage, these artists deal in a national custodial aesthetics for England. Richard Long, though the oldest named, is probably the artist with whom we would most easily associate Davies, if we looked at the superficialities of a working practice. Paradoxically, any comparison with Long opens up the debate central to art in the later part of the last century and into our own. We will come to that later.

Davies has exhibited internationally; in Estonia, Australia, Poland, Croatia, Belize, making statements that are site-specific but are still informed by his experience of his own locale. I feel that without bringing this experience to bear, his approach to these sites would be less involved, more superficial perhaps, and informed more by formal rather than cultural considerations. His sentiments can be seen to be universal amongst other marginalised areas of the world. His work is subversive, but not in the obvious, literal sense of the word, it is not illustrative or didactic, it is in itself subverting assumptions that are held about art.

The elements in Tim Davies' pieces are not just what they are, where they are. Rather, each ingredient, economically used, is symbolically loaded and carries a narrative threaded into the work, whether that narrative is immediately obvious to the viewer or not (as is often the case). Is that a weakness, the fact that one can overlook the 'meanings' and see only base material carefully placed and aesthetically displayed? I believe not. At the risk of over-interpretation, it could be said that looking at the work is an experience analogous with looking at a subaltern culture from above, as it were, a culture whose true identity is hidden under surface superficialities from those who are not of that culture, or are not anthropologists. Thus, to outsiders, that inner world, and we can see this in a discussion of Welsh-language culture for example, remains obscured. Most of its heart and soul, its meaning, remains hidden either through design or coercion. It is only to those willing to dig deeper through genuine interest and empathy that it begins to reveal its inner life and soul. Those people are rewarded by moments

of revelation and epiphany. Looking at, reading into and discovering connections and links unfolding ever outwards from the installation works of Tim Davies is an apt equivalent to that process of discovering a different culture hidden under a patina of 'global' similarities. Like discovering the prevalence of Santeria (Afro-Caribbean religious) aesthetics in contemporary Caribbean art; once we understand that it is there, it adds greater depth and involvement to the viewers' relationship with the works of art. Knowledge rather than an acquaintance. Davies' work operates as a corollary for Welsh culture, (which is willfully mistaken as English regionalism by many). To say that Davies' work is the same as the work of, Richard Long, is akin to saying that Welsh culture is just a variant of English culture. In other words; "for Wales, see England" as the *Oxford English Dictionary* used to have it. The fact that this 'truth' in Davies' art is hidden under a camouflage that appropriates the conventions of Western high art, late Modernist, minimalist trends, only emphasizes the nearness of the 'other' to the centres of the European mainstream.

<p style="text-align:center">V</p>

I hope I can be forgiven for continuing the comparison with Richard Long in order to explore the dichotomy between form and content mentioned earlier. Richard Long has said "I think all my works, my actions, have no meaning outside what they are"; a Zen-like statement which would have us believe that it is possible to make art that has no 'meaning' beyond itself. Long needs to be viewed in the context of post-war British art, and in that spotlit position quite a number of contradictions become illuminated. The echoes of Imperial adventurers stalking the 'unpopulated' and 'savage' parts of the globe, bringing them into the enlightened realm of the British Empire, becomes apparent. Significantly, when Long is not walking in the exotic vastness of formerly colonized territories in the Hindu Kush or South America, he uses the Celtic fringes of these British Isles as locations. Places where the population was systematically forced out in the Eighteenth and Nineteenth Centuries to provide a wilderness for the sport of English aristocrats.

This subliminal colonialist hangover in Long's work drew a sharp critique in the work of Rasheed Araeen, an artist born in Pakistan and working in England. Araeen put on an exhibition *When the Innocent Begins to Walk the World* in the Showroom Gallery in London in 1988. One particular piece, whilst a parody and appropriation of Long's pathways of stones gathered from various parts of the world "having no meaning outside what they are", was also in itself a powerful piece. Araeen arranged a pathway of bones on the gallery floor, calling the installation 'White Line Through Africa'. This work, which seeks to expose what Araeen sees as the neocolonial implications of Long's work might well be closer in spirit to the thesis of Tim Davies' work.

At the core of Davies' thought process made concrete in the work there is an attempt at a form of decolonisation, not only in the straightforward political-social sense, but questioning the way Western art has in the past insinuated its apparent content-less, apolitical stance into all corners of the world. Nothing less

than the decolonization of the aesthetic language is involved in these works. Where elsewhere, material and form, if we are to believe what Long has said, stand only for themselves, in Davies' work they carry meaning beyond themselves. In the same way as indigenous Welsh painters have decolonised the Romantic, tourist cliché in the landscape tradition, Davies does the same to formalism as presented in the latter part of the Twentieth Century.

<center>V I</center>

In Postmodernist works there is a tendency to caricature aspects of Modernism. Davies does not do this, his work is therefore of the late Modernist ethos rather than, in formal terms at least, Postmodern. His engagement with socio-political content however, shares a lot with post-colonial art, and that characteristic would align it with Postmodern artists who are involved in the process of decolonising art in order to address specific concerns that American Modernism (in the Greenbergian[14] sense) did not care to comment upon; issues such as race, gender, identity.

Davies circumnavigates the politics of nationalism by dealing directly with the 'real', with memory, with survival; reclaiming or re-appropriating from the mainstream hierarchy of art history, a mode of representation to do that with.

"Elusive truths are more easily caught in a small syntactic net" (to return to the quotation at the beginning of this essay, taken from Emyr Humphreys' 'Notes on the Novel')[15]. According to the *Oxford English Dictionary*, syntactic comes from syntax, a grammatical arrangement of words showing their connection and relation; or a set of rules for an analysis of this. Davies' visual language is a model of tight formal, visual syntax, whereby a net is formed that captures those elusive truths that many less stringent and economic, many more verbose artists, fail to catch.

In conclusion, I will attempt to refine what I tried to sum up about Davies' work at the selection for the Mostyn Open Prize in 1998. The work bears resonance that goes beyond its formal qualities, and this resonance comes from its knowing references to Wales' recent history of cultural protest. Sadly, that protest, whilst transforming the political and cultural landscape, is still hardly known to most of the inhabitants of Wales itself, much less the population of the world outside. It is a history that should be known, a history we in Wales should be proud of. In that same sense, we should be proud of the work of this singular artist: Tim Davies.

NOTES

1 'alice maher + tim davies', catalogue essay, Sue Hubbard, Oriel Mostyn.

2 *Realms of Memory; Rethinking the French Past*, Pierre Nora (ed), Columbia University Press, New York, 1996.

3 *Key Words. A vocabulary of culture and society*, Raymond Williams, Fontana Press 1988.

4 *Collected Poems 1934-1952*, Dylan Thomas, J.M. Dent, London, 1952.

5 Tim Davies' statement in the catalogue for *Borders*, an exhibition jointly organised by the Artists' Project, A Casa Moderna Galerija, Zagreb and the National Museum and Gallery of Wales, Cardiff, June to September 1997.

6 'Art and National Identity' *Art in America*, September 1991.

7 *Certain Welsh Artists: Custodial Aesthetics in Contemporary Welsh Art*, ed Iwan Bala, Seren, Bridgend, 1999.

8 *Watching the Fire-eater*, introduction, Robert Minhinnick, Seren, Bridgend, 1992.

9 *Emyr Humphreys: Conversations and Reflections* ed M. Wynn Thomas, University of Wales Press, Cardiff, 2002, p.168.

10 *Fusion: West African Artist at the Venice Biennale*, Thomas McEvilley, The Museum for African Art, New York, 1993.

11 *Six Voices from Spain*, Oriel 31 catalogue. 'The Rebel Tradition' José Jimenez.

12 A subaltern culture in critical writing is a marginalised, minority culture, and, more prosaically perhaps, a bullied culture.

13 'Blatant, Latent: Tim Davies', Martin Barlow in *Certain Welsh Artists*.

14 Clement Greenberg was the critic who more than anyone championed the art of Pollock, Newman and the others. He famously said; "Paint is paint, surface is surface".

15 *Emyr Humphreys: Conversations and Reflections* p.227.

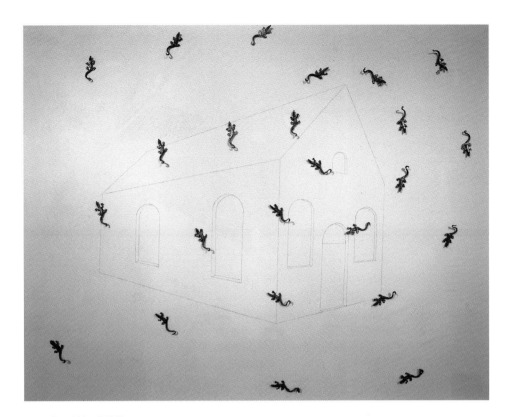

Paran Chapel (detail) 1993

following pages: Seven Vowels, wild and scattered parts 1-7 2001

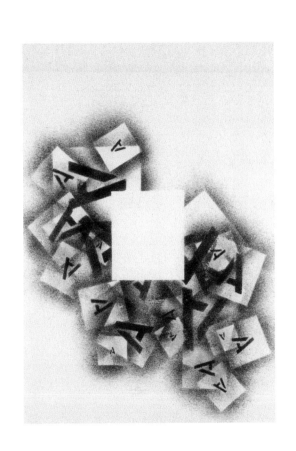

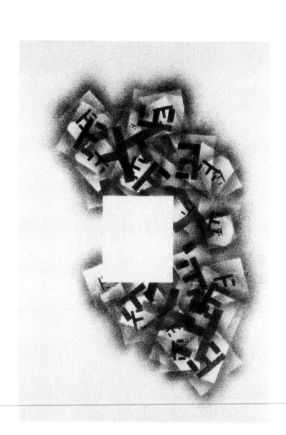

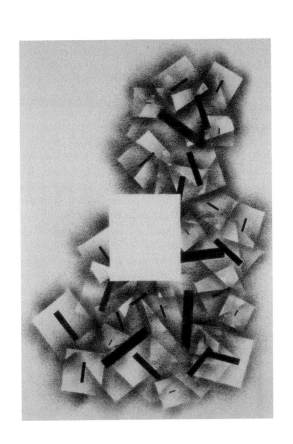

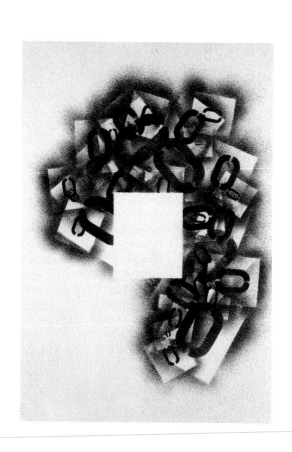

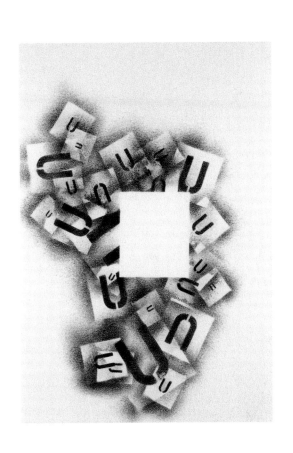

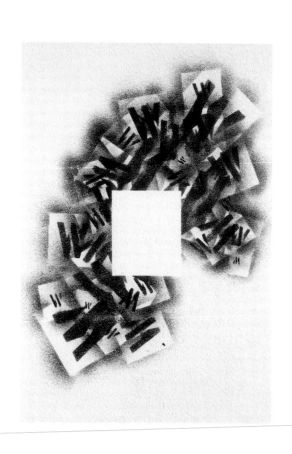

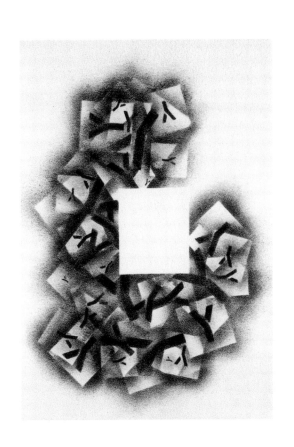

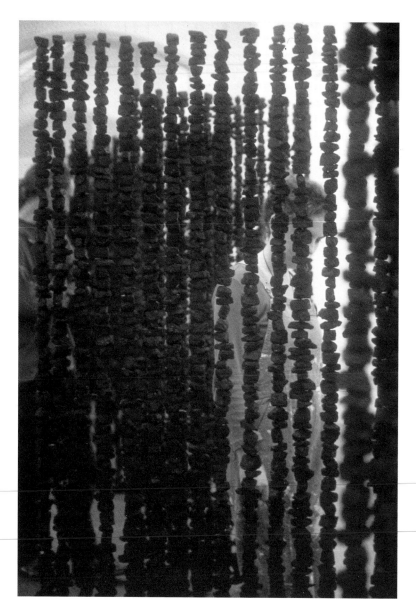

Black, black walls 1993, at East International, Norwich

FIRE

Fire is among the processes which define the work of Tim Davies. Although his work is seldom about fire, he appropriates the element as a means of communicating his ideas in connection with the issues he explores in his work. These issues concern the world he lives in.

Particularly, that world is Wales and its microcosmic character. The complex diversity of subject-matter and its intricate connections with culture and society, together with industrial and rural landscape activities, are reflected elsewhere. What takes place in Wales is indicative of wider, frequently global, concerns currently being addressed in other countries and their ideologies. Because fire is an elemental force, grounded in history and mythology irregardless of nations and creeds, Davies' work resonates with transcultural associations. To this end fire, in its many forms and allusions, is not necessarily the factor that drives Davies to express the variety of concepts he investigates, but is seminal to his means of expression. Accordingly, in the majority of his installations fire has been implicit. Sometimes his course of action is elucidated in the work itself, verified in 'Burnt Wall' (1993-4) and 'Continuum' (1997), where burning and singeing are the by-products of the process. In other pieces, like 'Matted' (1994), 'Capel Celyn' (1997) and the 'Nail and Screwdriver Drawings' (1998-2002), his methods of appropriating fire are less obvious, yet still fundamental to the creative act. While 'Matted' is intrinsically related to oil, an inflammable fuel, 'Capel Celyn' involved the melting of wax to cast 5,000 nails, and it is these artefacts in their raw, metal state which Davies heats before making the scorched impressions that comprise his nail and screwdriver drawings. Just as fire, a universal element and the stuff of much symbolism especially in Celtic culture, has many connotations, the art too reverberates with layers of associations and meanings. Thus fire is integral to Davies' system of resolution where the finished pieces invite further speculation.

Interpretation of his work rests in its visual appearance on two counts. First, much of Davies' art is site-specific and consequently tailored to suit the place in which it is made. Each time we see the works in a different space, we experience them in a new way and from a fresh perspective, even though the process, materials and form of the works are repeated, as for example in 'Parallax'(1998, 1999, 2000). In other words, it is the variation, or in Derridean terms, the difference, between the same works which affects our perception of it. By selecting one and not another, we inevitably draw attention to the existence of the latter, which encourages conjecture and correspondence. Hence, the more we encounter the work in its different permutations, the more meanings it evinces for us. These meanings may not necessarily occur to us even when we contemplate the work several times in one space – the alternative spaces in which the work exists resonate with different emotions and liaisons with those sensed in the initial space. Space is perhaps the operative word: as a concept its significance in this equation is powerful. Everywhere Davies offers us lacunae for consideration. And it is these spaces in-between the constituent parts of his works which are open to speculation on the universal nature of his art and its place in the international art scene.

Space and time are interrelated. Space is the idea that each of us forms and develops as a result of our sense perceptions, that other 'things' exist as well as ourselves. We describe these in terms of their position in space and distance from one another. Since we perceive ourselves as constant in having the quality of being the same always, time is involved. This space-time continuum, and indeed breadth-length variable, are encountered in Davies' 'Continuum' (1997). Its repetition of molecular structures and the implied infinity of the pattern suggests a Postmodern response to Brancusi's 'Endless Column' (1913). Both space and time are relative concepts since they relate solely to sensory experience. This is a human condition that takes no account of difference, and is truly intercultural and international. The Postmodern, post-structuralist ethic insinuates itself into the pieces Davies creates. His reductionist approach strips away superfluous matter, allowing the materials and forms to speak.

Despite, or perhaps because of this condition and the fact that Davies has not always lived in his native land, he has demonstrated his cultural and political allegiance to Wales as one of the country's most dynamic and innovative visual artists. His entrance into the Welsh scene occurred, quite appositely, at the National Eisteddfod, Neath in 1994 with his prizewinning installation, 'Black, black walls', which was initiated in Norwich in 1993 and reinstalled in Neath. The exhibit consisted of approximately 28,000 pieces of coal strung from ceiling to floor on steel wires. Effectively, they formed a series of screens through which the spectator could view the remaining walls, which cumulatively formed a dense, dark mass. The symbolism inherent in the materials of coal and steel was obvious. Here was a 'new' artist protesting against Heseltine's pit closure programme in autumn 1992. Coal was the lifeblood of the south Wales valleys; it was the main source of income, and provided power for heating and cooking in the domestic situation as well as being the reason for the development of the civic infrastructure there. But that was the past, and like the powers beyond Wales, Davies reduced this mineral to an impotent, decorative element, like black coral threaded on string. Nevertheless, the blood and sweat of those who toiled in the pits are implicit in the organization of the work. The layers of coal screens suggested the strata of the earth which builds up in density as one burrows to the coal face. Looking through these curtained layers, only black is visible in the centre, so that the spectator is confronted by an intense black mass, like a black hole in space. The attempts of the populace of Wales to retain their industrial heritage was prohibited by Thatcher. Her ministry is aptly communicated in the successive, vertical structures that resemble a series of portcullises. But the apertures at the edges are portals of promise: by allowing the light through, they suggest that the bleak outlook may be transformed and that Wales may rise like a phoenix from the ashes of its declining heavy industries.

Wales' social, political, economic, and cultural transformation were the objectives of the Beca group, some members of which visited the Eisteddfod. Small wonder then, that Davies caught their attention. Recognizing him as an artist who embraced some of their ideals, he was invited to join the group, which aimed to promote a sense of Welsh culture and identity. Its emphasis was on the visual arts, but practitioners of alternative arts were also included. Beca artists

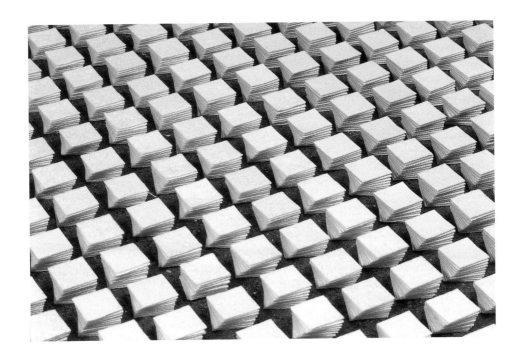

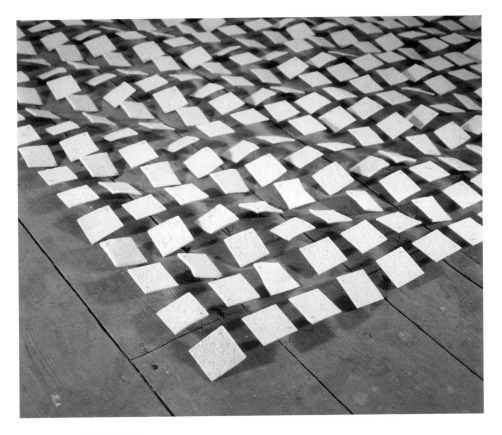

Parallax version III (detail) 1999
Parallax version II (detail) 1999

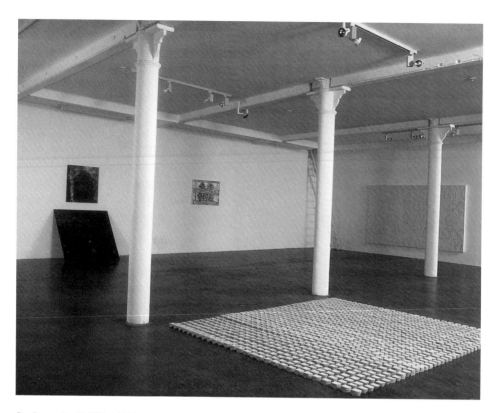

Parallax version III 1999, at 30 Underwood Street Gallery, Hoxton, London

created provocative works which were generally produced outside mainstream venues. That way the group didn't need to seek approval, and was able to reach a wide public audience in whom it sought to instill a Welsh consciousness, rather than one which was Anglo-centred.

The group, instigated by the late Paul Davies and his brother Peter in the early 1970s, was committed to reshaping the political and social map of their country. Distressed by its political and economic decline, they sought to fore-ground issues concerning the entire fabric of Wales. They did this by drawing attention to the impositions made on the country by a government that appeared to marginalize and disempower a nation which had hitherto contributed to the wealth of its imperialist neighbour. The first Beca exhibition took place in 1984, and by 1993 Beca was well known for its agitating tactics using the arts as a vehicle. Moreover, it influenced and encouraged a circle of artists whose empathy for Wales and its cultural concerns, including language, articulated these themes in their work.

Although it did not attract much attention outside Wales, Beca highlighted some of the themes also being explored internationally in response to changes in the political map of Europe; the expansion of multiculturalism; the end of the Cold War; the growth of the European Community; the spread of AIDS; the communications networking through faster travel and the Internet, which con-stituted a global village; the polarities of materially wealthy societies and the poverty of the developing world; immigration and human rights: all were given expression within the visual arts domain. They were sometimes manifested in the artists' search for a spiritual reality, an alternative means of transcending the plight of mankind and the rebounding results of greed and selfishness in all aspects of our lives. Throughout the world artists sought to communicate these concerns, often using shocking images in order to shake the public out of apathy and to persuade them to acknowledge and engage with issues.

It was not simply universal issues that internationally renowned artists were examining which were comparable to Beca, but also their means of expression. They used new techniques, and materials that were cheap or free, often recycling discarded matter (itself a statement about the condition of the planet). Sometimes materials were only a means to this end, with artists performing their art and dispensing with all but the minimum matter required to advance their message. Arte Povera and Minimalism are the recognized movements associated with such techniques and the concepts underpinning them, and they are reflected in Davies' work. Where works of art could still be made in paint, or involved the traditional materials of sculpture, Beca, like its international coun-terparts, focused on the processing of the concept as opposed to the final artefact, which was frequently ephemeral.

Thus Davies was a natural member of Beca. Shortly after finishing training as a painter, he realized that by restricting himself to paint, he was limiting the kind of works that he could make, and consequently limiting the extent of his commu-nication. Although he may be described as a sculptor, he has no formal training in that discipline. He believes this to be to his advantage, for were he familiar with the sculptor's methods and techniques, his spontaneity in identifying unorthodox

materials for the expression of his ideas, could be stifled. His art is process-led, which explains his use of diverse, and often novel, materials.

Davies acknowledges that fire is a controlling influence on how he processes those materials in works that are original in both practice and artistry. However, it is Davies who controls the fire. His knowledge of its effects is manifest in the crafted structure of his work. The economical use of materials and the formal quality of his work underlie its universal appeal. He reduces most of his art to basic forms. Squares ('Parallax'), rectangles ('Llwch-Maesgwyn') lines ('Continuum') and most recently points that assert themselves within the square ('Screwdriver Drawings') are the motifs that advance the notion of discipline in his practice. These, and previous works, form grid patterns; his organizing principle is perpetuated in geometrical construction, which is his way of responding to the measured, mathematical proportions which we as rational beings identify in the structure of the universe. Consequently the works evoke stillness, a calm which invites contemplation.

Nevertheless the materials, and what Davies subjects them too, suggest that all is not what it appears. Underneath the ordered appearance we sense a feral power indicative of the chaotic and contradictory nature of the universe. Organic matter like coal, wood and woollen fabrics signify warmth, comfort and growth. But their proximity to cold, hard metal objects such as steel, nails and pins introduce connotations of unease and disquiet. It is difficult to avoid identifying these polarities as gender related. Such combinations and juxtapositions suggest the emotional character of the works, and contribute to their transnational appeal. By persistently reducing everything to its minimum, Davies allows the material – the medium – to be the message.

Therefore, Davies maintains, he is not an abstract artist because narrative is implicit in his work. Yet arguably, it is the abstract quality together with the paucity of materials of the work which impart the universality of the message, whereby viewers extract their own meaning. Where, for example, 'Burnt Wall' (1993) might appear to be about arson attacks on holiday homes in Wales to a Welsh observer, it may communicate a different message to spectators abroad. Therefore, when seeing the same work "in say Dusseldorf, or Venice or New York, one would not necessarily think of arson but of Arte Povera".[1] It is unlikely that this would be the case if Davies produced figurative works. By honing the content to its essentials only, excluding superfluous matter and simplifying its structure, the underlying concept may be assimilated by an international audience. "[This] shows that it is possible to have something very, very specific, take it on an intelligent journey formally, and then produce it, and then it can remain as both specific and non-specific at the same time."[2]

This is hardly surprising given the nature of the artist and his determination to create works which communicate effectively to all people no matter what their politics, culture and history.

After ten years of exploring the use of flames and heat as a means of extending his artistic vocabulary, Davies continues occasionally to exploit the processes connected with fire because "it reasserts itself as a significant force"[3], and one which he has not yet laid to rest. Indeed, his resolve to create by fire may be

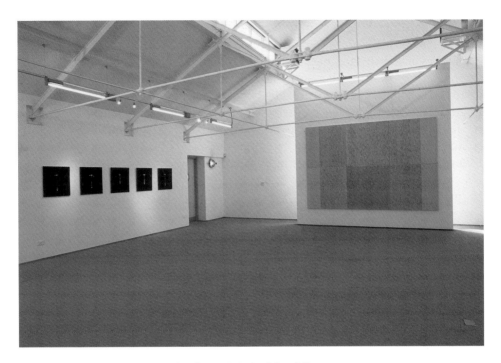

Continuum and Still Lives (Hammers) 1999, at Ormeau Baths Art Gallery, Belfast

interpreted as his passionate response to the common concerns of mankind: "Because a fire was in my head".[4] These words of W.B. Yeats are echoed in Davies' instinctive urge to register his feelings for Wales, alias the globe.

His visit to Tallinn, Estonia in 1993, where he made 'In Parenthesis' advanced his notion of affinities between Wales and those countries where dispossession and reclamation were of political importance. Estonia, in its sudden re-emergence as a country, where confusion and uncertainty were the inevitable outcomes following the exuberance of initial celebration, had suffered marginalisation and oppression as part of the USSR. A country at the same time lacking financial investment and without an adequate industrial infrastructure with poor communications, it had echoes of Wales. Although its people had regained their identity, they were disadvantaged by poor economic and social conditions. The 'in parenthesis' of the title discloses Davies' attempt to signify that transitional space with which the people had to come to terms, in order to become a fully fledged political enterprise. Davies appropriated a space in a derelict house (one of the few 'exhibition' spaces available), but one which was ironically commensurate with the project, the house having been ransacked. Davies saw this as a metaphor for the country itself. The house represented a vacant lot dispossessed of all character, a space between habitations perhaps, like the lacuna in which the Estonians found themselves. Davies took the naked floor as his canvas. He glued tens of thousands of matches upright on the floor, and then set fire to them so that a carpet of charred and bent matchsticks remained. Davies' burnt floor reminds us that the period between death and rebirth is painful, but also tells us that the outmoded order must be purged and dispensed with, to make way for progress.

It is fitting that Davies chose to call this piece 'In Parenthesis', also the title David Jones gave to his epic poem[5] recalling his experiences as a foot soldier in the Great War. The poem deals with a period of some six months from late 1915 to mid-1916, leading up to the Battle of the Somme, which Jones chose because the war subsequently "hardened into a more relentless, mechanical affair, [and] took on a more sinister aspect"[6]. The 'parenthesis' refers to the transition between one state and another, when man-to-man armed combat was superseded by the wanton destruction of the machine.

Although a perfunctory glance might suggest that destruction is the signature of Davies' art, the outcome is positive. His methods and intentions were similar in his site-specific installation in Lodz (1996), Poland. The country was reasserting itself following its repression by the Communist regime and martial law, to emerge as a republic in which people were united in solidarity by their common culture. As in Tallinn, Davies' site was a vacant house where even the original parquet floor had been purloined. However, this time he selected a column form which he subsequently clad in matches before setting them alight. The charred black column recalled the columns of coal in 'Black, black, walls'. Normally columns are the load-bearing members of buildings, and this one, punctured with bent and blackened 'nails', was contemporaneous with the plight of the country. (Importantly, another piece instigated here was 'Tatters' (1996), utilising rags bought from a travelling Russian market. Davies pushed the fragments of material into the soft plaster of the wall.)

Likewise in Zagreb in Croatia, a country which has also been subjected to disturbances in its national development, Davies' burnt floor piece corresponds with those of Tallinn and Lodz, but this time matchsticks were not the chosen medium. As in the previous two displacement studies, many parquet floors had been removed from their original dwellings, and Davies again focused on the notion of the ground being withdrawn from under the people's feet. Unlike Estonia, where there were few exhibition spaces, in Zagreb Davies was invited to create a piece for a museum. The theme of displacement was continued by co-opting old pieces of parquet flooring which he subsequently burned to a rich black. He repositioned the pieces on the floor of the museum, effectively laying a black timber carpet on the museum's natural parquet floor.

Davies consolidated the concepts of these three site-specific pieces in 'Burnt Parquet' in the National Museum of Wales in Cardiff in 1997. The main component is architectural – all the pieces were 'housed' in buildings, commodities integral to the validation of the concept. Because the work expresses displacement, two interesting implications emerge. Architecture, also called the Mother of the Arts, and the Museum, an establishment committed to the display and veneration of the arts, are the ironical overtones inherent in this burnt floor piece. A vast number of blocks used to comprise a parquet floor were deliberately burnt to produce the densely charred sections which Davies laid on a polished, pristine parquet floor in the museum. Displayed amongst the riches of the museum's collection of artefacts in glass cases, the contrasting black of Davies' overlay and the honey coloured hues of the museum's floor, was distinctive and dramatic. This alien carpet and its velvety texture, with its overtones of ethnic identity, was effectively accommodated within a (Welsh) cultural space. In laying it out, Davies was careful to align the parquet at similar angles and dovetailed joints to those of the floor, which results in a further ordered pattern in the design, thus perpetuating the notion that this is art. Carl André had already paved the way for such artworks, maintaining that his work was 'materialistic and communistic'[7] in terms of the materials and the accessibility of his floor pieces. Indeed, Davies could claim the same for his work. Like André's 'Magnesium Square' (1969), for example, Davies' is also a flat structure 'grounded' in gravity. The charred material with its black dust spilling over the sides of the notional carpet gives further credence to this work as a moveable object, now deliberately sited in a specific context. The connection between the Eastern European countries' transitional stages of political ideologies in the former Communist Bloc and those of Wales is clear when considering the origins, both conceptually and in terms of process, of the floor piece. The charred timbers are a metaphor for change, and suggest the flux in Welsh politics. Ultimately, the installation declares a repositioning of order, in which structure and form are harmoniously re-composed after disorder.

This piece especially reminds us of the formal qualities of Davies' art. Always there is a precision manifested in his meticulous approach to form. Not only does this illustrate the controlled thinking in the genesis of each piece, it also accounts for each work as an original, site-oriented, pragmatic structure, however superficially similar they may appear across venues. Collectively, these

ephemeral works perpetuate the notion of time as cyclical, in the same way as diverse civilisations. This transnational aspect adds to the gravitas of the work and demonstrates Davies' ability to communicate to differing audiences, irregardless of specifics. This is perhaps best conveyed by reinventing the fragile carpet, which pre-empted a later project where Davies recycled parquet timber.

In 1999, Davies came across some discarded mahogany parquet in a salvage yard in Swansea. The wood had originally been imported from the central American rainforests. Disappointed at the waste, and conscious of the alarming rate at which the rainforests are disappearing, Davies decided to square the circle and send the timber back to Belize. He shipped it via Bristol, a port which had grown rich on the slave trade. In the Belizean Cayo district, he painstakingly relaid the sections of parquet in a clearing in the rainforest. This time though, the wood was left in its natural state; it required no further intervention from Davies to make powerful statements about colonisation and slavery, as well as referencing re-cycling. The treated timbers will naturally decay to form nutrients for new trees to grow over and through the 'Returned Parquet'. Eventually Davies' sculpture will disappear without trace, bringing to mind the walks taken by Hamish Fulton that 'Leave no Trace'[8].

A successful project of this nature requires teamwork. Davies has a creditable record in collaborative artistic ventures. He may work in isolation but he is conscious of the explorations of other artists. Moreover, his art makes a significant contribution to projects where like-minded artists generate ideas among the group. This has been established in projects like *Site-ations* (1998) and *Locws* (2000 and 2002), in which site-specific works are situated in public places where local people are invited to interact with them. Always the history of the specific location is considered in the particular site selected by the artists to express their empathy with the spirit of the place.

As with many site-specific artworks which depend on where they are placed as well as their location, the general public as spectators often have to rely on secondary evidence in order to see them. This is the position with 'Returned Parquet'. Like Fulton[9] and landscape artists such as Richard Long, Andy Goldsworthy and David Nash, a photograph of the installation is admissible evidence: the integrity of the artist in each case is not disputed. Two factors contribute to this kind of evaluation. Primarily, the artists have proved themselves in works made prior to the site-specific pieces and, just as importantly perhaps in an age where the emphasis is on visual culture, we trust photographic evidence. Even in a sophisticated technological society in which we know the camera can lie, we nevertheless trust our own eyes. Seeing is believing, whether or not we have in mind the digitally manipulated image. There are alternatives to the photograph, of course, as Long and Fulton demonstrate. The former frames text pieces, poems and also places maps on gallery walls while the latter, who also uses text, evokes the temporality and topography of his walks, with drawings and even by chanting.[10] All of these methods, including photographs, retrospectively conceptualize the simulations of walks all over the world.

With a title like 'Camera' (1994), we might expect to see a photographic image from Davies. But he is far more devious and ironic. In a manner comparable to

Camera 1993

that of Ian Hamilton Finlay, he makes leaps between the image and its verbal counterpart.[11] Davies' perversely titled 'Camera' is a poem, experienced by the viewer on a gallery wall. It consists of a series of letters on horizontal sections of woollen blanket. Each line is composed of words, but there are no spaces between them so that the spectator is encouraged to spend time deciphering the poem. It reads as fragments such as we might find written on a holiday postcard, with the possible exception of the last three words: 'burn burn burn'. The blankets Davies collects for his text pieces are acquired from charity shops, and retain the stains and marks left by the original owners. Hence the cloth, although recycled, is fragmented and suggests the division of families, or even societies, which were once comforted by the blankets. Just as the blankets were an aid to warmth, here Davies heats them by using a blowtorch to scorch stencilled letters onto the fabric. The frozen moments referenced by the camera lens are thus transformed into scraps of poetry, while the message in shorthand suggests excitement in rapidly scribbled, essential notes which may later be expanded.

The use of text to explain, extend or elucidate images is not new. This legacy of Western art runs from the pre-Renaissance to the Pre-Raphaelites, and the relationship between image and text was further exploited by the Cubists in the early Twentieth Century. Throughout, artists have used text in conjunction with their images, and sometimes, in conceptual art, instead of an image. In 1995, at the National Eisteddfod at Abergele in 'Alphabeca', Davies scorched letters and the 'ineffable symbols of sound'[12] on to sections of woollen blankets which were the visual equivalents of the accompanying Beca group's continuous chanting from the Welsh alphabet. Davies' blanket pieces were subsequently hung to create an exhibition of alphabetical forms familiar to Welsh speakers. The woollen, lettered squares also related to rural life and the Welsh hill farmers who "penned a few sheep in a gap of cloud".[13] Flocks of sheep are marked as a means of identification, and Davies' use of a blowtorch to brand his wool patches with Welsh recalls the actions of the farmers.

In his manipulation of the stencils, Davies inevitably created patterns some of which conformed to his grid formula, while others are randomly scattered. The patterns in the latter occasionally play with scale when only one letter-form is used, whereas multiple letter-forms are controlled by their homogeneous size. Davies' technique of singeing the woollen ground confuses our perceptions. By careful timing, he guides the density of the blowlamp's action and can simulate creases, rather like modelling with paint, so that the lettering appears to rest on concertinas. This three-dimensional ambivalence is advanced in 'Wild and Scattered' (2002), where Davies "plays irreverently with language".[14] His self-contained series of text pieces are informed by the seven Welsh vowels scorched onto fabric. The resulting patterns are as various as they are intriguing. The 'I' is perhaps the simplest form and composes the most abstract pattern in being repeated as a horizontal, vertical and diagonal. The 'Y' remains a distinct letter form, despite Davies' attempts at distortion by scattering the letters or arranging them in blocks. By manoeuvring the blowlamp, Davies initiates light and dark areas in the letters and the background or the foreground, depending on how we view the pieces and the attendant 'shading'. Accordingly, he not only plays with

language, but also with spectator perceptions. Ultimately, the work derives from Davies' speculation on both literacy and language, including the artistic vocabulary of tonal and spatial values, and how we perceive them. These credentials are compounded by the fact that the individual modules can be arranged in almost endless permutations, which accounts for Davies' collective description of 'suite'. Like a deck of cards, and the analogy is reiterated in the title 'Wild and Scattered', they can be 'read' from diverse angles: the trick is perhaps in how we perceive them.

There can be little ambiguity in the way we read the sub-text of 'A Place I Know Well' (2002). The title suggests a return to the familiar, the warm and the sense of belonging evoked in previous works. But Davies subverts all this in the form. First, he has created a *livre d'artiste*, traditionally a handmade book under the control of the artist from start to finish. Only fine quality materials are used, and they are printed in very limited editions, signed by the artist and are commensurately costly. Secondly, the content of these books is also precious. But Davies' book is mass-produced on cheap materials. His text utilises clichés found in estate agents' windows, or holiday brochures, which are committed to hard sell. Hence the sense of belonging of the book's title is denied to the reader. Underlying this disaffection is a larger concept in which the original occupants of a place are denied those features they associate with it. The loved and known is subjected to commercial spin couched in language to appeal to visitors and buyers seeking a financial investment as opposed to domestic comfort. 'Pretty as a picture', 'within easy reach', or 'a stone's throw', provide Davies with a 'golden opportunity' to expose the insincerity of both message and medium. The hackneyed phrases presage the death sentence of the place he once knew well – it was his home. He cannot identify with the way it is appropriated and publicized. The book's affinity with 'Camera' (1995) is evident. The tourists' superficial remarks which were burnt into the blanket are given a sinister complexion in the equivocal vocabulary of commerce.

Language as a corollary of culture germinated in Davies' mind when his grandfather, who was one of the last of his generation in Solva to speak Welsh, died in 1994. This personal loss contributed to Davies' exigency for developing the theme of language. Moreover, his predilection for language coincided with its appropriation by post-Feminist artists who were also dealing with minority groups within a majority culture in the USA. Davies' interest in language as a means of communicating in images reflects the ambiguity with which a number of artists are cognizant when their work is perceived in terms of the visual image only. Cindy Sherman, Jenny Holzer and Barbara Kruger are perhaps best known for visual art inextricably linked with text and, in some cases, text as image. Their theses subvert the textual exegesis as the voice of power. In some senses Davies' approach to text is similar, but often his message has an additional frisson, as in 'Nage' (1994). Conceived as a memorial, it resembles a tombstone and is an epitaph to all past Welsh-speakers. Davies' anguish at his grandfather's death, and the fact that he took his language with him, is universalized in the rectangular blanket emblazoned with the recurring word 'nage'. Thus 'Nage' (a form of 'no' in Welsh), is more than a protest, and has been perceived as covering similar

emotional territory to Dylan Thomas in the villanelle to his father, 'Do not go gentle into that good night'. Fire represents passion while blankets are a means of dousing its flames, so that ultimately this work is shot through with alternative allusions.

The realization of loss, or dispossession of homeland, is often recognized when we are distanced from that place. So it was with Davies, who first recognised this sense of separation before his return to Wales, in 1994. In what in retrospect was an epiphaneous installation in view of all subsequent work, his 'Flags over Solva' (1992), was an attempt to reclaim his village. He took five fifteen-foot poles and attached a pennant to each one before locating them around the village and coast over the course of a week. The pennants fluttered like ensigns when the sea submerged the greater part of the poles at high tide. Because flags are empowered with allusions of territorial ownership and political authority, they are powerful status symbols, often regarded with reverence. Damage to them is at best an affront, at its worst a hostile act – consider the burning of the American flag in Afghanistan in November 2001. Understandably, when Davies' flags were removed by an unknown person from where he had placed them, and repositioned on alternative sites during the night, he was at first perplexed. But on reflection he was gratified by the thought that someone had engaged with his project and were prepared to go to some lengths to declare their own convictions.

The flags were anonymous to the extent that they could be relocated by another individual who temporarily professed his rights. Nevertheless, Davies' flags and the Stars and Stripes Jasper Johns created in 1954-5 bear comparison. Through its medium, encaustic laid over newspaper fragments, Johns' flag literally bore the marks of authorship – his fingerprints are imprinted on the image. Ultimately, Johns' flag belongs to him, although its design implies the unity of the States whereas Davies' represents division and disruption of the status quo by reinstating the identity of the village.

This ephemeral work spawned a further installation about Solva: 'Solfach: Sea, Gorse and Phantoms' (1992), created for a gallery space. The materials, timber and ropes, were culled from skips, in character with Davies' propensity for recycling. He created oars from the wood, which he then burnt so that the charred, blackened texture variously implied purging, death and renewal. The colour was also in keeping with the theme of phantoms, suggesting haunting images, often with a sinister presence. The 'phantom' of the title actually refers to the RAF Brawdy base, and the Phantom jets which scream across the Welsh landscape on low-flying exercises. Suspended from ropes in the gallery space, the oars moved rhythmically in currents of air, like ghostly wings detached from their fusilages, filling the space with an uneasy quiet. But the oars simultaneously recalled the sea with its lyrical movement, and Solva's gorse-lined coast. This evocation of his home is a powerful signifier of the complexities and ancillary associations of how memories haunt us, both collectively and individually.

As the memorial to Solva was adapted for successive gallery spaces, so too was Davies' 'Burnt Wall' (1993-4). The process of fire with its constituent associations of movement in smoke and flame is perhaps most evident in this early work, where the lighting of each of the individual matchsticks on the wall create

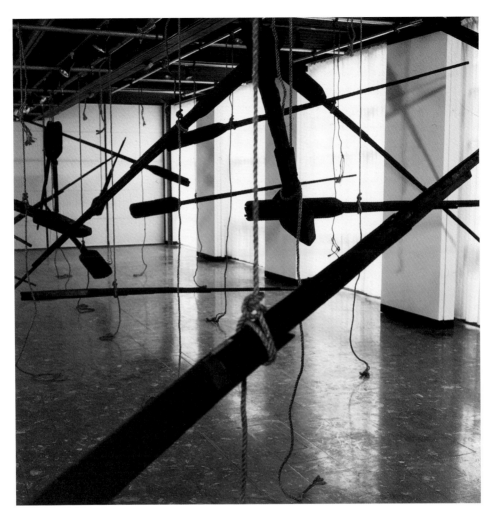

Solfach 1992, at Howard Gardens Gallery, Cardiff

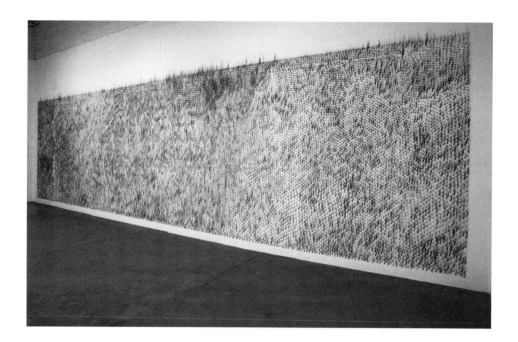

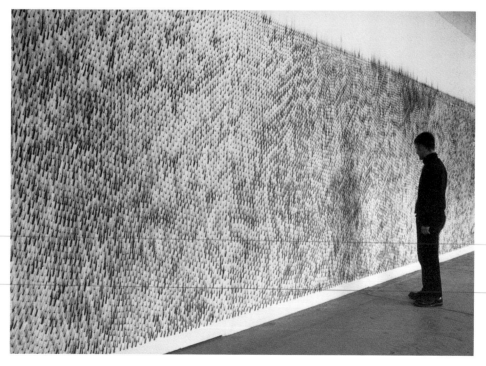

Burnt Wall 1993, at Warehouse Artists' Studios, Flexispace, Norwich

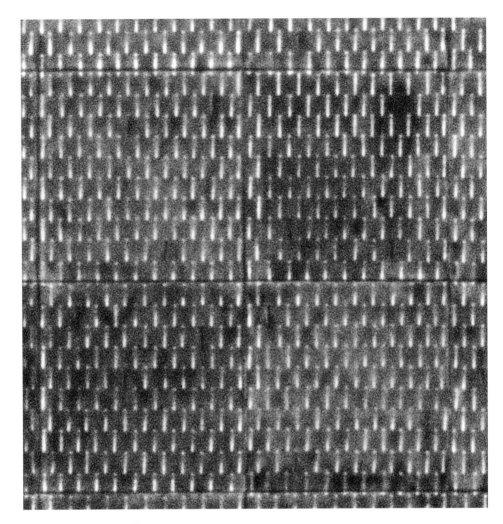

Gwaith dim gwaith (detail) 1996

a formal, ordered pattern, not dissimilar in concept to 'Black, black walls' (1993), demonstrates the full cycle of fire. The blackened, random pattern on the wall resulted from the matches burning to varying degrees so that the entire area took on a kinetic effect as the the viewer approached it. From a distance, the organisation of the patterns resembles an ariel view of a raging forest fire which consumes everything in its path including structures that are both natural and man-made.

'It Hurts Him to Think' is the title of a poem by R.S. Thomas, and it is clear in his Welsh landscape 'Llwch-Maesgwyn' ['Dust-Whitefield'] (1996) it hurts Davies to think about pollution of the land. On a visit to an opencast site in 1995 he witnessed "a huge black rectangular field with vehicles noisily dragging and scraping away the coal. The top soil, having already been peeled back".[14] It reminded him of "The/ industrialists ... burrowing/ in the corpse of a nation/ for its congealed blood".[15] Davies' ironic title is as provocative as his reaction. Commencing with a series of square blankets stretched like canvas over frames, he outlined seven rectangles on each one before rubbing coal dust and charcoal into the shapes. But the dust bled outwards beyond the definitions of the 'fields', and Davies' efforts to confine the pollutant were in vain. This metaphor for the coal industry's broken promises focuses on landscape, for Davies sees "landscape as important as architecture, as signifier of 'home' and 'place.' The blanket suggests this familiarity/security and the dust signifies the disruption of this".[16]

The unemployment that followed the closure of the coalfields gave to Davies the title for his ensuing piece, 'Gwaith dim gwaith' [Work no work] (1996), which was directly inspired by his teaching experience in Swansea Gaol. Wood-working and craft tools were laid out within a wall-mounted, reinforced glass lidded box. The knives, chisels and other potentially lethal weapons were outlined in paint, so that the negative shapes cast by the tools allowed for their absence to be noticed at a glance. The box struck Davies as emblematic of the prisoners' situation, who were "dispossessed, not just in the economic sense, but in the familial sense".[17] Davies assimilated these feelings in a wall comprising forty-eight two-foot squares of stretched blankets. Dismissing the obvious, hazardous tools, he opted for an innocuous screw nail as his singular motif. Alert to the formality of the pattern in the prison tool box, he placed rows of identical screws at regular intervals on the blanket beds, before scorching the entire surface. The result was a series of charred square blanket pieces bearing a pale repeating pattern created by the screws. When the pieces were assembled vertically on the gallery wall, some of the screws defied gravity and remained clinging to the fabric by a thread. Davies' empathy with the inmates' right to dignity may be due to the Blanket Protest undertaken by IRA prisoners in Northern Ireland's Maze prison. Refusing to wear prison uniforms, these self-styled 'political prisoners', clad themselves only in blankets in defiance of prison regulations. Davies' own defiance against dispossession underpins his work: his choice of the screw can be interpreted as a protest against the hierarchical power relationships of the prison wardens.

Almost by osmosis, Davies' fascination with time and how outlooks and perspectives alter, has evolved and is given expression in a number of works on paper, in his series of nail and screwdriver drawings (1998-2002). Conceptually, these works compare with 'Dust-Whitefield', where leaves of cheap, thin paper

are placed one on top of the other. Using a red-hot screwdriver or nail to burn holes at regular, parallel intervals on paper, a grid of points results. The process is methodical and timed. Each contact point between the hot metal and the surface lasts for a count of four. Up to four holes can be made before the implement cools, and its mark-making properties are nullified. The effect on pages underneath the top sheet varies from dark brown impressions to minimal indentations. In this way, Davies quite literally marks time and space.

The concept behind these works on paper and the installations, both of which were constructed as panels in the studio before being installed in their respective galleries, is grounded in 'Continuum' (1997). In it a cream blanket perpetuates the soft textures of the familiar, but this time the pattern is scorched onto the woollen ground in vertical lines. When contemplating this work, the lines convey a sense of movement as if they are about to continue beyond the work's upper reaches into space, or alternatively be driven into the ground. Horizontally too, the lines apparently waver, rather like the quivering images we see through fierce heat, reminding us that the work exists within the space-time continuum. The drawn lines have been burnt onto the material by a red hot nail. The singed lines, like scars of flagellation, imply damage and violence. Yet being evenly spaced, the lines are denser and accordingly wider in places, depending on the intensity of the heat of the nail, and suggest the furrows of a ploughed field. Attached to a wall, 'Continuum' advances Davies' notion of the equivalence between architecture and landscape.

In 'Tatters' (1996) Davies combines the wall metaphor, an architectural structure redolent with symbolism, and his materials. The genesis of this work lies in Poland, where the site-specific project's initial stimulus emerged from his wandering around a market selling second-hand clothes. The clothes were little more than rags, but poverty-stricken people were buying them. Davies bought some too. Using a wall as his canvas, he drilled a series of holes at regular intervals, before inserting a piece of rag. This comment on society's hardship and fragmentation was adapted to gallery sites in Wales. He again drilled several thousand holes in a controlled and considered manner directly into the walls of Oriel 31, Newtown (1996) and Oriel Mostyn, Llandudno (1998), amending each version for the specific architectural contexts of these galleries. In the various versions of 'Tatters', each hole was planted with small fragments of blanket resulting in a series of rosebuds emerging from the wall's surface, perhaps indicating renewal and growth. These organic motifs disturbed the rigid pattern so that control is not absolute. Rather, the dismantling of the family, a metaphor for society, is at the core of this work, given its context. Either way, the work portends changes for future generations.

Unwittingly, the latent changes suggested by this work were practically applied when Davies repeated the installation in another gallery, where there were no walls suitable for drilling. It evolved into 'Parallax' (1998), a floor-based work. Unable to bore holes into the floorboards, Davies took dressmaking pins and impaled the small squares of blanket on them, before sticking the pins into the floor. The immediate appearance was a free-floating, rectangular grid of tiny squares. Nevertheless, the original concept was "... still there, that thing about

installing **Tatters Version II** at Oriel 31, Newtown, 1996

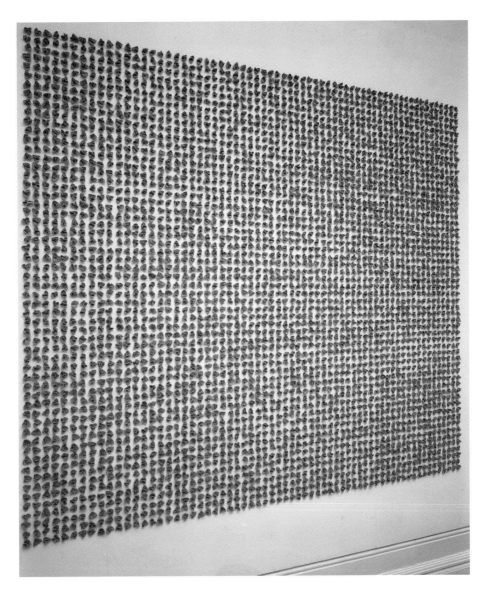

Tatters III 1998 at Oriel Mostyn, Llandudno

cutting up, fragmentation of a familiar material ... which signifies comfort, home, security. There's the cutting up and then trying to put back together, so there's an element of deconstruction, an element of reforming, reclaiming, to make this form, but at the same time I wanted to be very direct with the materials and not tell a lie, so they float off the surface ... by means of a dress pin, this time the pinhead is revealed."[18]

The concept was perpetuated in 'Parallax III' (1999), although there were distinctive alterations to the installation. The work was again placed on the gallery floor, but this time the pins were abandoned, and layers of the small blanket squares were piled on top of one another, in essence, a grid pattern of stacks. In a further variation, the stacks were of unequal heights, depending on the number of pieces in each pile. Davies has created a palimpsest, a field of soft squares. Each layer, or page, has its own story embedded in its fibres, and these successive stories relate our history. The geometric form of the whole piece is architectural, yet the softness of the blankets suggests that history is vulnerable, and subject to being re-written.

The accumulative and inherent symbolism of the blankets, together with the signature stains of the original owners which Davies is disinclined to erase, references the pioneering work of Joseph Beuys. His favoured material, the felt blanket, conceptualizes themes such as protection and security, together with growth and life – generally corresponding to feminine values. Such correlations are apparent in Eija-Liisa Ahtila's recent installation in which a series of red flannel blankets bear the text message: "Give yourself a present. Forgive yourself".[19] Davies' art, like that of Ahtila's, shares the same currency as that of Beuys in its environmental concern. Consequently the allegorical intention of Davies' work is assimilated and understood by an audience familiar with Beuys.

Wax is the paramount material of 'Capel Celyn' (1997), a work made in response to the drowning of the village when the Tryweryn valley was flooded in 1964 to create a reservoir to provide water for Liverpool. When Davies was given a rusty nail from Tryweryn, the idea of making a memorial to the people forced to leave their homes took shape in his mind. The nail was cast in wax, to produce a further 5,000 waxen nails, which were eventually installed in an allocated space, forming a rectangle on the gallery floor. Nails were symptomatic of the drowned village, their whiteness suggesting death. The message was elegiac, representing both mourning and praise for a lost way of life. The wax, most commonly used in candles – symbols for light and warmth – was transformed into votive memorials, as the title implies.

Davies had previously used the 'lost' wax process to cast the lizard motif for another memorial to Welsh life and culture: 'Paran Chapel' (1993). The lizard, a symbol for metamorphosis, is associated with Lucifer. The lead lizards were superimposed in a spiral pattern over a faint crayon outline of a chapel near Solva, which had been stripped of its roof lead. Traditionally, the chapel was one edifice in Wales that sustained the Welsh language. Once the authority of the chapel declined, it was inevitable that the language, and a particular aspect of Welsh culture, would wane. No longer a central part of Welsh life, many have been closed, deconsecrated and sold to be converted into houses or used for other purposes. The chapel as signifier rather than saviour, is the focus of Davies' lament.

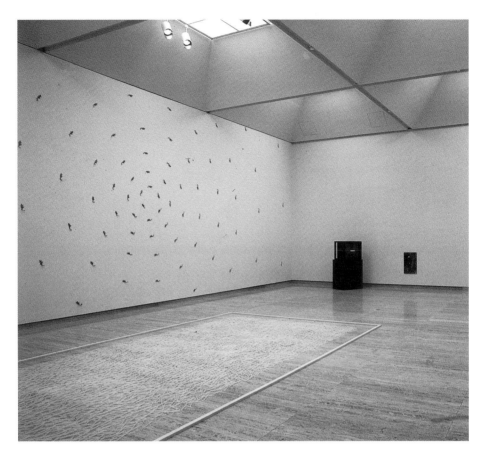

Paran Chapel on wall, Capel Celyn on floor, 1998, at the Art Gallery of New South Wales, Sydney, Australia

Postcard Series II no. 6 2002

Postcard Series II no. 7 2002

'Paran Chapel' was executed before Davies returned to Wales. The first piece entirely conceived and made in Wales was 'Matted' (1994), the result of the discovery of feathers blemished by tar and oil, on the beach near his studio. Davies collected hundreds of tern feathers and subjected them to the ravages of engine oil before making a grid with them on the gallery wall. During its showing, the oil continued to trickle down the wall creating black calligraphic patterns, so that the quills documented their own epitaphs daily. An example of 'process art', pioneered by Eva Hesse in her use of latex which disintegrated rapidly over the span of an exhibition, Davies' piece accentuates his process: through the stickiness of the oil, the feathers adhered to the wall for the duration of the show, testimony to its powerful adhesive properties and its resistance to solvents. 'Matted' is an attack on global pollution, specifically from oil. It preceded by two years, the *Sea Empress* spillage disaster at Milford Haven, when Pembrokeshire's unique coastline counted the cost in wildlife. From a distance, and because of the distorted feathers, the piece resembles a cultivated field of tall grasses. This view returns us to the notion of landscape, reflecting that wider, less specific, interpretations are also applicable.

This comes as no surprise when surveying Davies' work. In one of his first pieces in which the archetypal theme is tragic love, as addressed in Shakespeare's *Romeo and Juliet*, Davies' subtitle 'A study for lovers and strangers', considers dispossession. The piece originated from the Bosnian crisis. Davies had seen a newspaper photograph of two lovers from opposing sides of the conflict, lying side by side in no-man's-land, killed as they tried to escape the violence. United in death, the lovers were subsequently separated, and buried within the confines of their own ethnic camps. The installation consisted of suitcases (alluding to the elopement), hanging precariously from the ceiling, with ash dust (to which we all return) spilling out of them, providing a primitive carpet beneath. Dim, red lighting haemorrhaged out of the suitcases containing red light bulbs. Indicative of blood spilling, as well as fire, red also suggests the passion of both the lovers and of the opposing forces in their fight for what they believed was their right. Davies' title for this work 'Dispossession: a study for lovers and strangers' (1994), implies the universality of the theme, which transcends cultural and temporal barriers.

In 'Postcard Series II' (2002) Davies begins with a provincial subject and subsequently subverts it by apparently making it disappear, so that the background, or context, becomes the subject; neither black nor white, neither subject nor context takes precedence. This ongoing project began with a postcard image featuring a conventional lady in Welsh costume situated in a Welsh landscape. Davies cut around the stereotypical image so that a blank silhouette, a negative, remained in the rural setting. With successive trials, the image of the woman diminishes as the landscape invades her space so that the final iconograph in the series shows no trace of the woman. When the collection is viewed, the series of diminishing voids shows the lady eventually vanishing. This demolition of a cultural icon is not as straightforward as it seems. By extracting the iconic stereotype, Davies puts the emphasis on the landscape and the way it is used. Places which are identified as pretty, or beautiful, are often sold off, or ring fenced, for the purposes of tourism. The concept is compounded by the postcard

with its additional allusions to tourism, fleeting visits, superficial looking at sites of interest and picturesque landscapes. The subject – the national emblem – is subsumed by the landscape, but the landscape in turn becomes the subject. In another series of postcards the notion is explored further in relation to the site-specific object.

In 2000 Davies realized an ambition to create a huge site-specific enterprise in Swansea. Using powerful blue lights, he bathed the castle in blue for the duration of a month. As dusk fell the castle gradually took on a deepening blue. It was reduced to an almost surreal edifice, where the strange, unnatural hue made it appear as a cardboard cut-out amidst the urban buildings around it. With the ivy's stranglehold on the ruined tower, the castle lost not only its history, but its power. Davies calls it 'Blue Funk', an epithet weighted with meaning, the slang for a state of great terror. This state is redundant, which is especially obvious in the photographic evidence of the fortress, where adjacent buildings are lost against the black sky: only a segment of a distant terrace is visible. Davies' choice of blue honours the filmmaker Derek Jarman, who used blue to neutralize the image in his work, *Blue*. Blue has alternative connotations in the canons of art history. From the 70s onwards, Anish Kapoor adopted intense blue pigments to symbolize the primeval force, while Yves Klein appropriated the radiant blue of summer skies as a declaration of freedom, and his famous 1960s 'Leap into the void'. "The void as shape, as physical presence, may remain the 'same'"[20], and a metaphor for eternity, as manifested in Kapoor's sculptures, thus recalling the lacuna, or liminal interfaces, in Davies' art. Consider blue as the colour associated with melancholy, exemplified by Picasso in his blue period, and also remembrance, as for example in A.E. Housman's 'A Shropshire Lad' and the "blue remembered hills".

Arguably, all of these allusions can be found in Davies' continued experiments with blue, which proceeded from the castle, prompting the questions: "What do you with something which is very vast, very big and very site-specific, and therefore very temporary?" and "How can I make a kind of equivalent on a different scale?"[21] Davies considered how to reinstall the subject, the content, and the object which the castle had become under the influence of the blue floodlights. When posing these questions a couple of months later, Davies studied the image on the picture postcard he had made of the castle. The castle was reduced in scale – it had become physically very small, it had lost its power, and was no longer an object of fear. What remained was an art object, but the subject, the ruined castle, was sublimated to a Romantic image. The castle was minus its history, or as Tony Conran describes it:

> The castle didn't rate
> - Or not much – before
> - ...
>
> 3
> Even within talkshot
> It seemed ignorable. As I'd say,
> 'There's a very little castle.'
> Now upon the sloping lawn

For the first time
I attend to it.

4
Under sentence
The past exerts itself,
Resists shrinkage.
Though continually it slips'
Lets go of its space
(– How small these ancients are! –)
Yet here is a castle.

Var. XVI 'Hiatus in Swansea'[22]

It struck Davies that these reflections could apply to most Welsh castles when they are literally downsized on postcards. The picture provides visitors with proof of their experience of the actual castle, but often they only see the shrunken image. All they have done is look at architectural remains devoid of their particular history, thus stripping the subject of its potency. The superficial encounters of the visitors devalue the monument's credibility and the negation of its original function ensure the castle's fictionalized, mythologized and roman-ticized status.

Determined to re-establish the subject, Davies took a blue biro (popularly used to write messages on the back of picture postcards), and methodically scored straight, even lines across the image, vertically, horizontally and diago-nally. This is a rhythmic, temporal process, in which Davies took time to cover the image with a blue veil. In essence, he deconstructed the subject, and in doing so, puts the onus back on the viewer, who may enquire: 'Why has he done this?' Hence, we might consider how the image looks without the blue veil, which is tantamount to taking a visually stimulated mental leap. Consequently, we might then contemplate the function and history of the castle, and try to imagine what it originally looked like. Thus, by deconstructing the castle Davies actually assists in its virtual re-construction.

The ongoing projects in which Davies is engaged confirm his commitment to practice and his desire to create dynamic and stimulating works. Ultimately, these works provoke the spectator into reflecting on issues that affect the world. Even though the catalyst for these intriguing creations may be Wales, they com-municate in the diverse language of art, being unified by a visual aesthetic. By continually exploiting his materials, indeed often appearing to reinvent them through radical methods of process, he makes the familiar strange. The unex-pected happens, arouses wonder and invites speculation. Whether through his allegiance to fire, manipulation of light, juxtapositioning of materials, text as image, and the ambitious site-specific installations, Davies' art remains original and compelling. But it is the concepts underpinning the work which elevate the results of his imaginative impulse and confirm his place in the contemporary international arena.

Anne Price-Owen

Notes

1 Peter Dormer, quoted in 'Fragments', *Tim Davies: Continuum: exhibition catalogue*, Martin Barlow, Glynn Vivian Art Gallery, Swansea, 1997, p.13.

2 Tim Davies, quoted in Barlow, *ibid.*, p.13.

3 Tim Davies in conversation with Anne Price-Owen, 14 October 2001.

4 W.B. Yeats, 'The Song of the Wandering Aengus'.

5 *In Parenthesis*, David Jones, Faber and Faber, London, 1937.

6 *Ibid.*, p.x.

7 Carl André, quoted in *Oxford History of Art: After Modern Art 1945-2000*, David Hopkins, Oxford University Press, 2000, p.144.

8 *Wildlife – Walks in the Cairngorms*, Hamish Fulton, Edinburgh Pocketbooks, 2000, p.202.

9 *Ibid.*, p.192.

10 A CD rom is included with Fulton, *ibid*.

11 Cf. *Green Waters: an anthology of boats & voyages: published on the occasion of an exhibition at The Pier Arts Centre, Stromness*, Alec Finlay (ed.), Edinburgh: Pocketbooks, 1998, for Ian Hamilton Finlay's poem, 'The English Colonel Explains an Orkney Boat', which is the exegesis on a relief sculpture of a lemon in the accompanying exhibition.

12 Ivor Davies in *Yr Wyddor*, Tim Davies & David Greenslade, Gomer, Llandysul, 1998, unpaginated.

13 'A Peasant', R.S. Thomas.

14 Davies *op.cit.*, 14 October 2001.

15 'It Hurts Him to Think', R.S. Thomas.

16 Tim Davies, *op.cit.*, invitation card.

17 Tim Davies in conversation with Michael Nixon, Oriel 31, Newtown, 17 January 1997, quoted in Barlow, *op.cit.*, p.18.

18 Tim Davies, quoted in Martin Barlow, 'Blatant, Latent: Tim Davies', *Certain Welsh Artists*, Iwan Bala (ed.), Seren, Bridgend, 1999, p.152.

19 *Eija-Liisa Ahtila: Real Characters, Invented Worlds*, Susan May, Tate Modern, London, 2002), unpaginated.

20 *Anish Kapoor: Making Emptiness*, exhibition catalogue, Homi K. Bhabha, University of California Press, London, 1998, p.27.

21 Davies *op.cit.*, 14 October 2001.

22 *Castles: variations on an original theme*. Tony Conran, Gomer, Llandysul, 1993, pp.36-7.

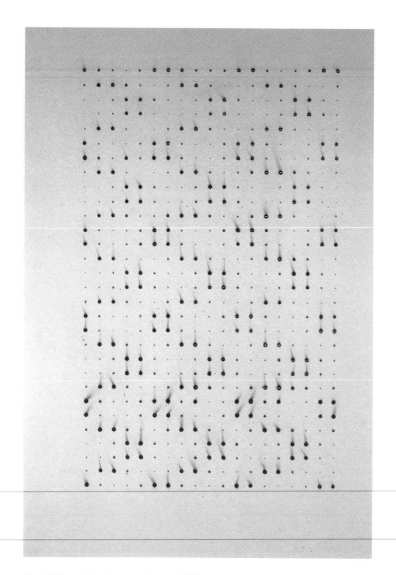

Untitled (Screwdriver drawing no. 2, part I) 2001

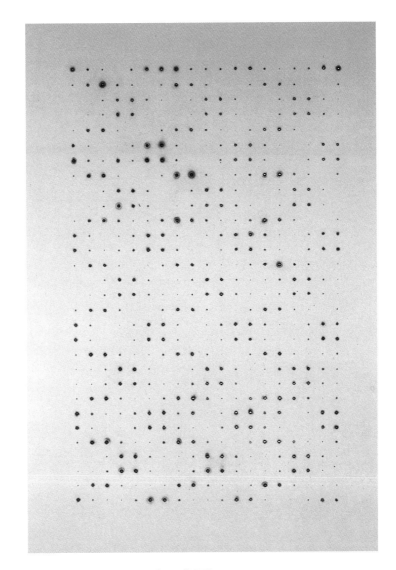

Untitled (Screwdriver drawing no. 2, part II) 2001

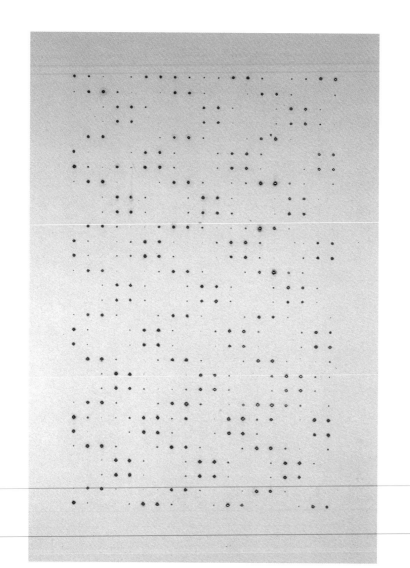

Untitled (Screwdriver drawing no. 2, part III) 2001

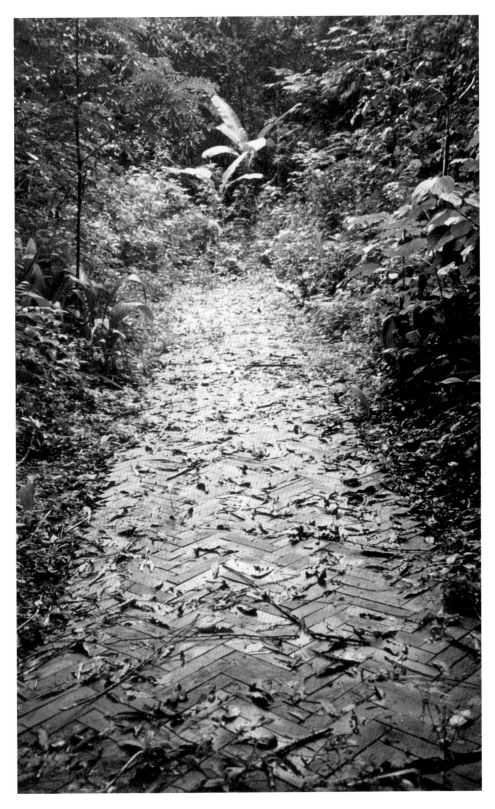

Llawr Fforestfach/Returned Parquet 1999, Poustinia Earth Art Park, Belize, Central America

Untitled (Screwdriver drawing no. 4 part I) 2001

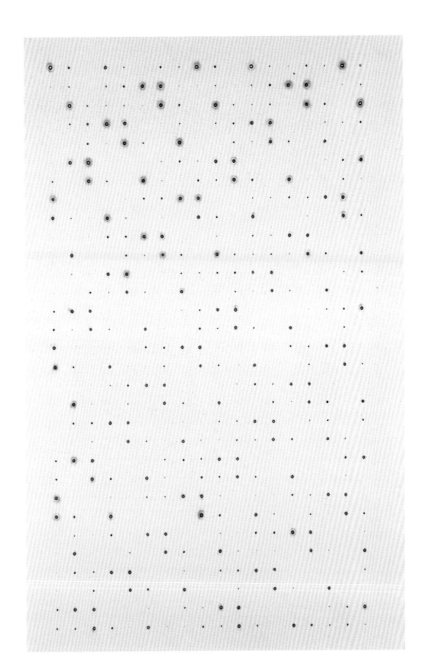

Untitled (Screwdriver drawing no. 4 part II) 2001

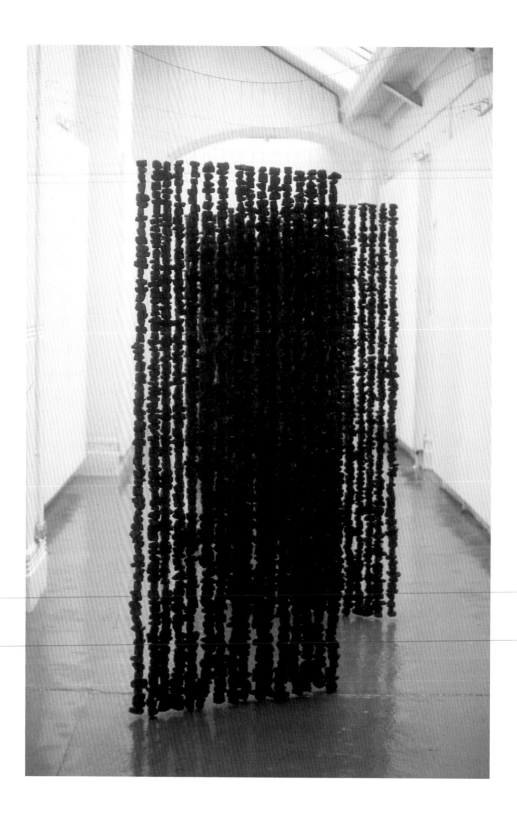

Black, black walls 1993, at East International, Norwich

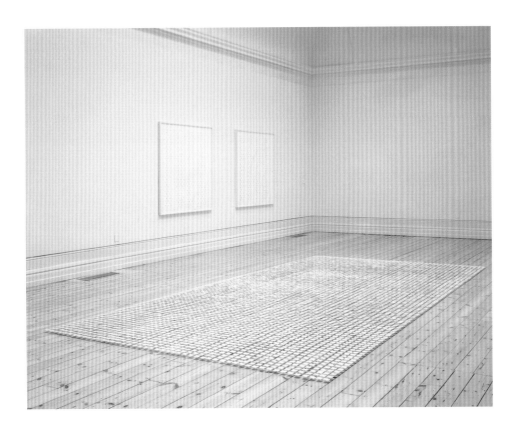

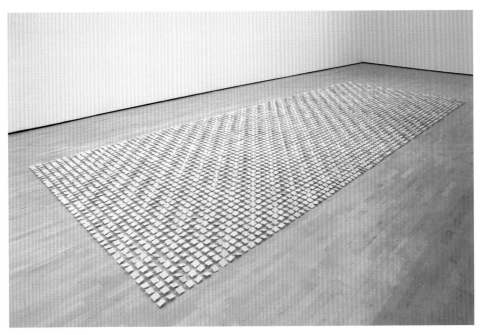

Parallax I 1998, Oriel Mostyn, Llandudno
Parallax II 1999, Ormeau Baths Gallery, Belfast

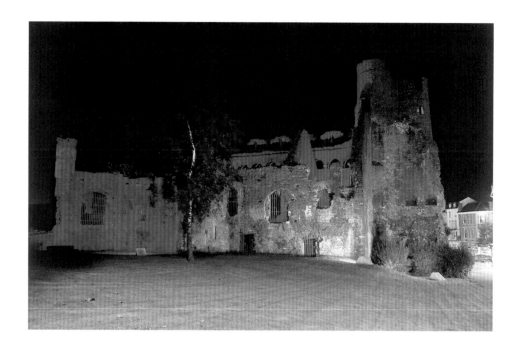

Blue Funk I
Blue Funk II 2000, *Locws International*, Swansea

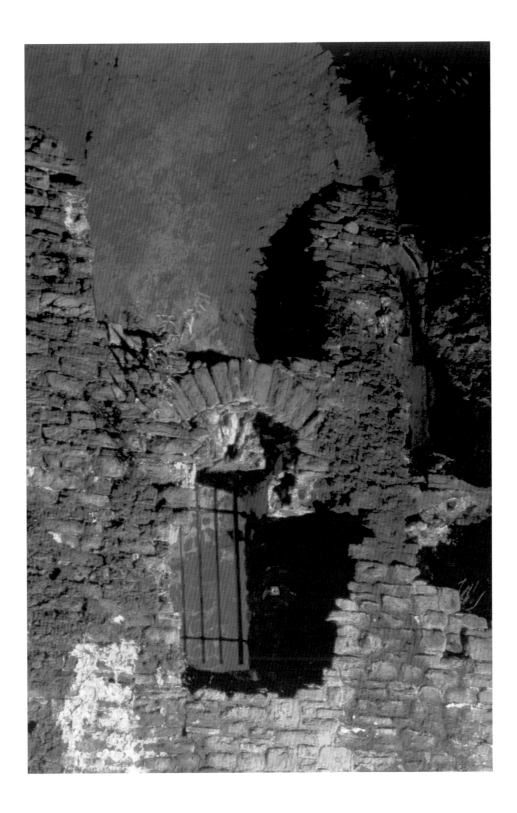

Blue Funk I (detail) 2000, *Locws International*, Swansea

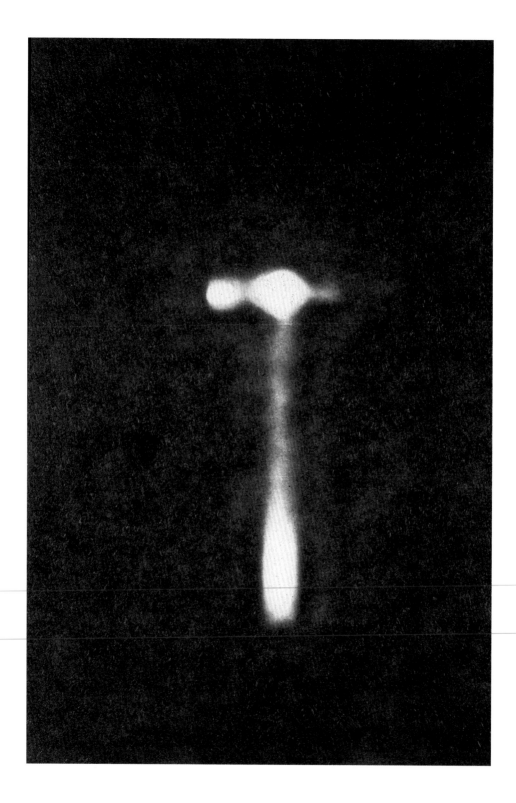

Still Lives (Hammers) 1999

Still Lives (Clamps) 2000

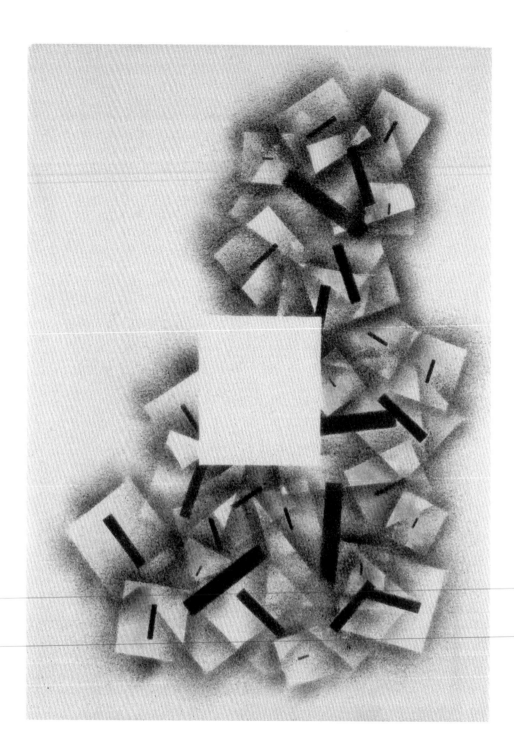

Seven Vowels, wild and scattered part 3 2001

Seven Vowels, contained and still part 3 1999

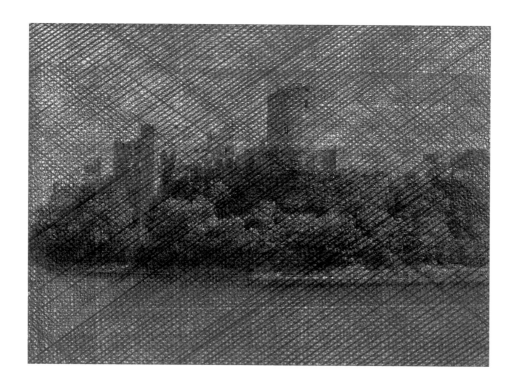

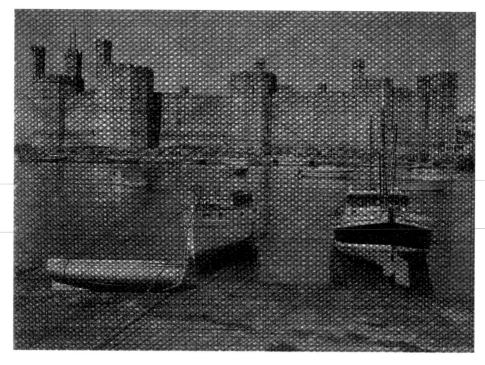

Postcard Series I no. 1 2002
Postcard Series I no. 2 2002

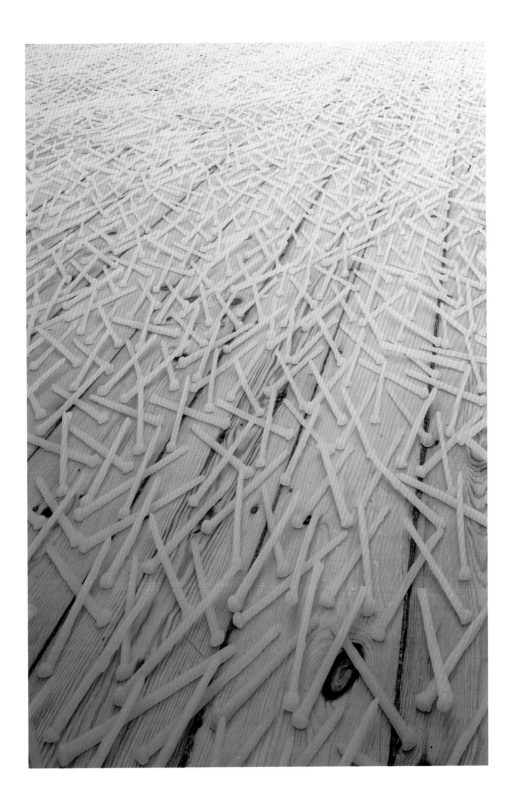

Capel Celyn (detail) 1998, Oriel Mostyn, Llandudno

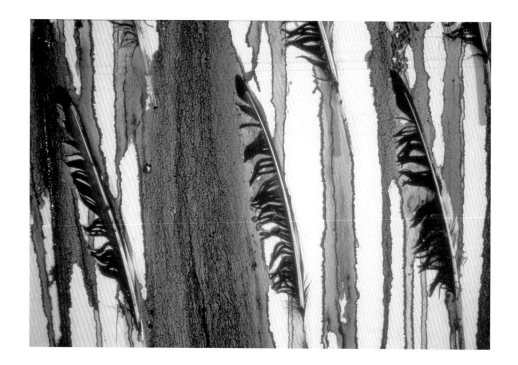

Matted (detail) 1994, Mission Gallery, Swansea

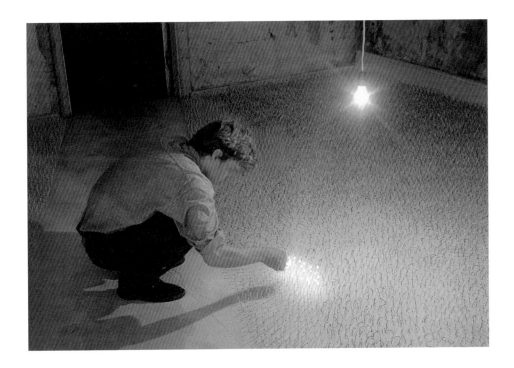

Installing **In Parenthesis** 1994, at derelict house, Tallinn, Estonia

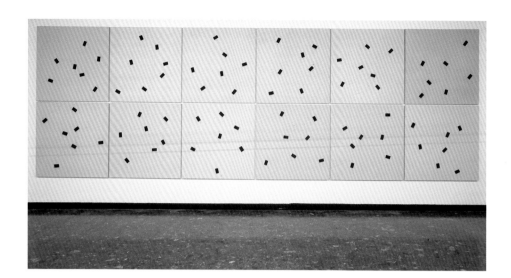

Llwch-Maesgwyn 1996, at Howard Gardens Gallery, Cardiff

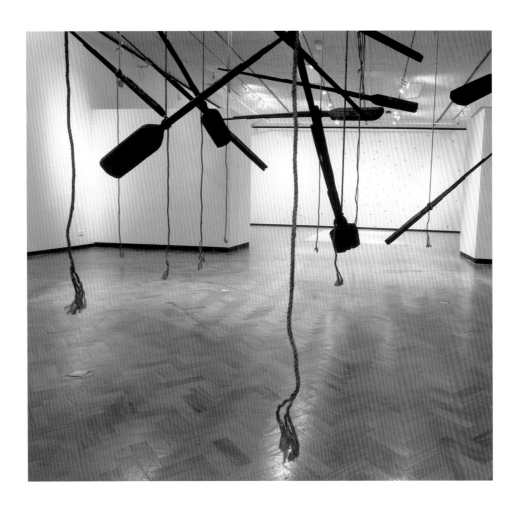

Solfach 1992 at the Glynn Vivian Art Gallery, Swansea

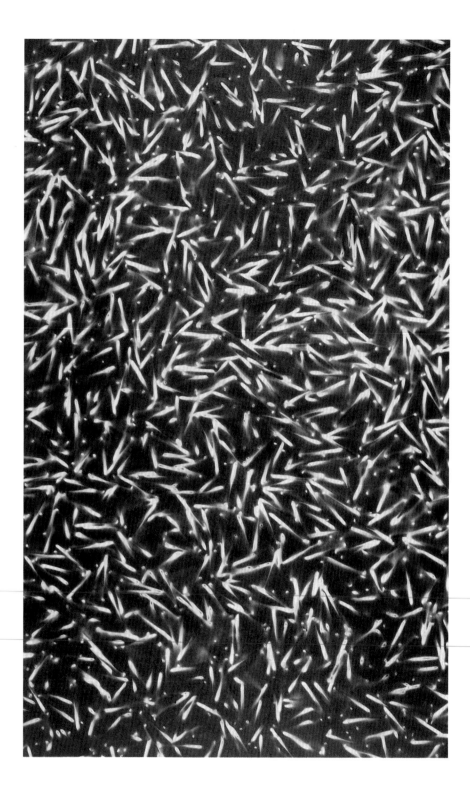

Scattered (detail) 2000

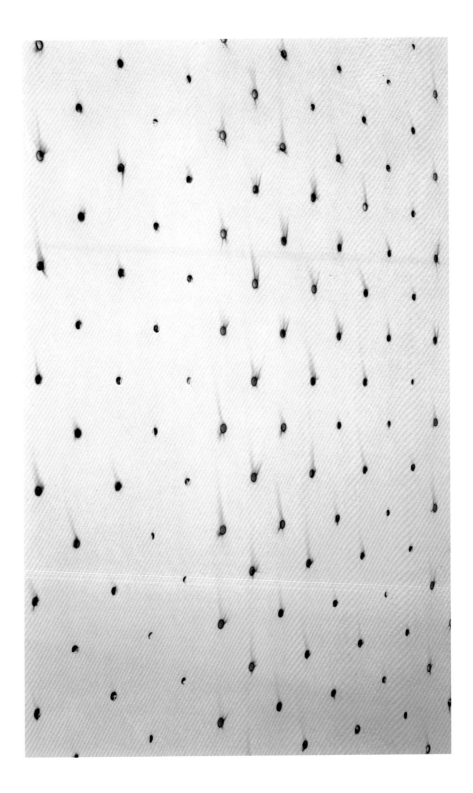

Untitled (Nail drawing no. 3 part I) (detail) 1998

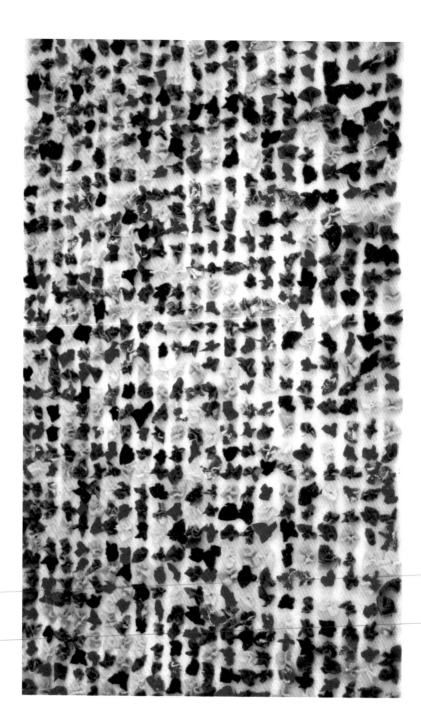

Tatters 1996, at derelict house, Lodz, Poland

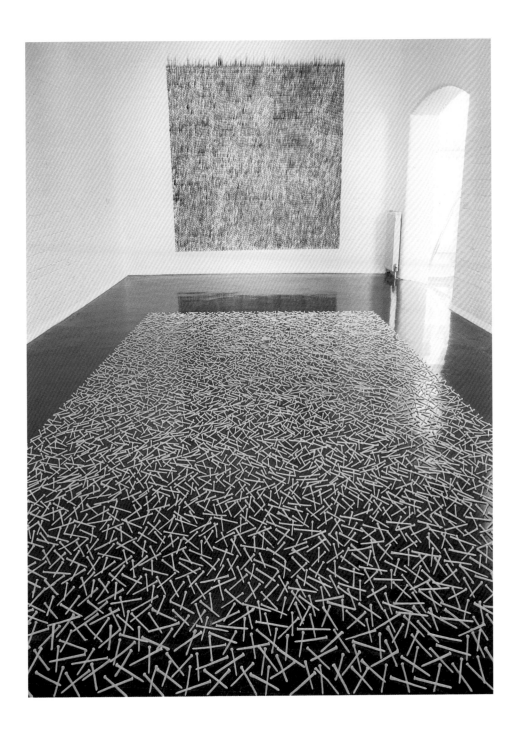

Burnt Wall and Capel Celyn 1997 at Spacex Gallery, Exeter

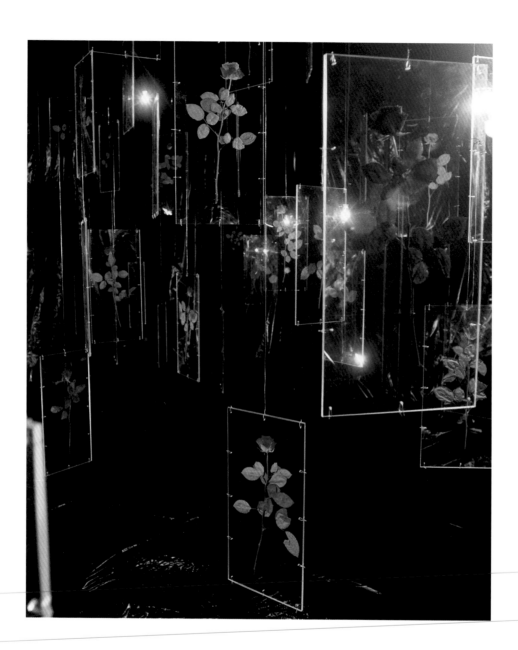

Caress (detail) 1995 at the Glynn Vivian Art Gallery, Swansea

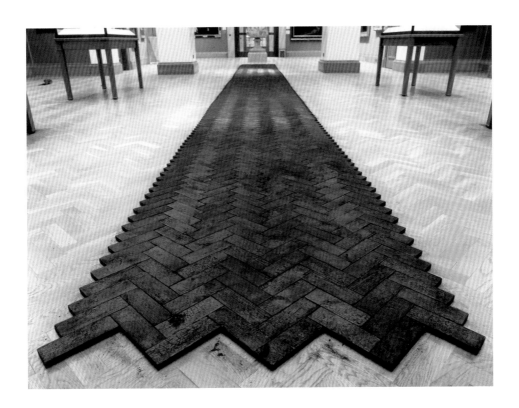

Burnt Parquet 1996, at the National Museum and Gallery, Cardiff

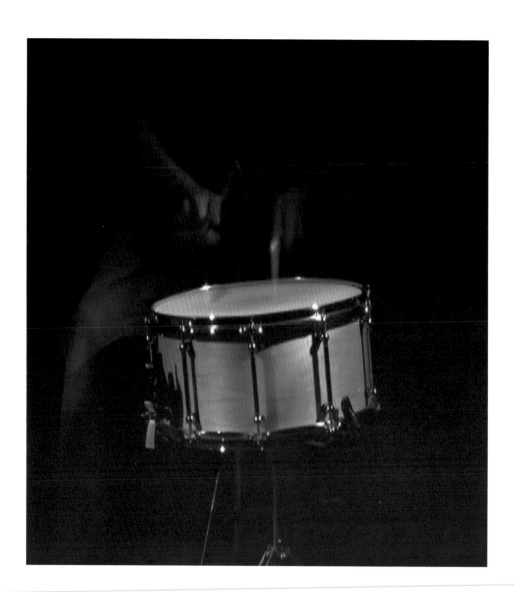

Drumming 2002

PROCESS IN PRACTICE

Having been invited by the publisher to write some notes on my working process, I'm going to consider five pieces of work as examples, focusing on their conceptual development and practical resolution. In doing this, I am not attempting to promote my aims in making the work as most important when interpreting that work. Indeed, some of the essays in this book demonstrate how far other people's interpretations can differ from my own intent. Barthes[1] has shown us that the author's voice is in fact irrelevant in deciphering the meaning in a piece of work and since Foucault[2], the artist's biographical details can be seen only as elements within a larger framework of discourses in which the art work should be considered. However, I cannot deny that my personal experiences affect my work, and the context in which I conceive and make the work is inherent in it. In this I align myself with other artists interested in cultural identity – my fellow Beca-members in Wales, for example and others from further afield whom I admire, such as Willi Doherty, Tracy Moffat, Rasheed Araeen and David Hammons. I therefore offer the following notes on my working process as a means of demystifying it for those who are interested in how I make work, but not as a dogmatic sign-post to understanding it.

'Flags over Solva/Fflagiau dros Solfach' remains a significant personal breakthrough. The object is presented as it undeniably is – a group of tall flags fluttering. The sand within which they stand undeniably exists – a village on the edge of sea and land, a point of transience between solid land and the timeless, liquid sea – timeless but changeable. But land is changeable too – building, roads and communication plethora and ownership. Solid land is commodifiable. It is bartered over, it changes hands, it changes in monetary value, it remains in memory – familial and cultural. It is claimed, fought over, reclaimed again and shaped. The tide recoils and returns twice in a day. Silt and sand gather in millimetres behind the flag creating and briefly constructing new land, but the flag is already there. The new land is unbartered, unlegalized and undreamt of. But it is there briefly. It soon falls back but for one moment it was there and my flag was there. It was there as land for a moment, it existed, and in its existence, for that moment, it was free.

I'm looking at a sepia photograph of a young girl on a bike in the middle of the street sometime in the early 1940s. A girl belonging to a family belonging to a community belonging to a culture. My mother.

Any culture must face up to its evolution. It naturally occurs. Geographical and economic shifts. Witnessing a rapid change, I would say a violent and aggressive change of hands is different. A change which is much more to do with the haves and have-nots. The gulf between disposable and unobtainable wealth is laid bare.

Every time I visit Solva I notice that the shops are catering less and less for the year-round villagers and more for the holiday trade. In winter the village is quiet, many houses in darkness awaiting the next family to arrive in the spring or anticipating the owners' visit to decorate before the 'season'. My grandfather, a staunch socialist and Chair of the local council in the 1950s and 60s, tried to

prevent Solva becoming a part-time village, owned by the few 'haves', unattainable for the 'have-nots'. He drove his car back and fore over drying concrete to prevent it setting around a gate, and he cut chains which tried to stop people from entering public land in the National Park. A 'have' had decided that the land should be his. Though my grandfather managed to stop this particular example of territorialism and appropriation, the village itself is now only accessible to those who can afford house prices well out of the reach of most locals.

My flags were a gesture of reclamation and de-colonisation in the village where my mother grew up and I spent long summers at my grandfather's house. 'Flags over Solva' was made when my grandfather was alive, much to his amusement. Following his death, my grandfather's house is now a holiday home too.

'In Parenthesis' – in October 1993 I accepted an invitation to take part in an Estonian exchange with five other East Anglia-based artists (I was living in Norwich at the time). In June 1994 we arrived via a flight to Helsinki and a ferry crossing the Baltic Sea to Tallinn. For me personally, this remains the most influential of the trips I've taken. The sea was extraordinarily calm throughout the three hour crossing. Seeing the spires of Tallinn slowly rising from the water in the distance brought a real sense of finally leaving the security and recognition of Western Europe in Finland and stepping into another zone. A different era almost, politically and culturally. I was put up for my six-week stay by one of Estonia's foremost artists, Jaan Toomik (later to represent his country at the Venice Biennale in 1998). He is a truly great artist and person. We hit it off well and spent many hours talking about Estonia and Wales, differences and similarities. He told me about life under Soviet occupation. Hushed evenings in friends' apartments. Fear of speaking in opposition to the 'party' line. A real threat and experience of being 'grassed' to the local K.G.B. Being arrested and held for questioning for several days as an art student for simply drawing the port of Tallinn. Conscription to the Soviet army. A posting a thousand miles away from home. A friend's suicide under pressure of the brutality of this regime.

To hear of events so harsh and extreme contemporaneous to my own life, to a man my own age, was sobering and shocking to comprehend. He and his friends embraced me warmly. In contrast to the collective recent tragic memories and taut existences, a discernible philosophical purity and spiritual clarity ran parallel. This I felt powerfully and humbly. Most obviously, on a material level, there was no room for slack or ostentation. Out of necessity things and obsessions had been pared down. A genuinely sparse existence. Each object and moment gaining a heightened sense of itself. Economics had created its own metaphysical value. The excesses of the West from food, to T.V. to toiletries, to fashion, seemed at once vulgar and wasteful in the extreme.

The singing revolutions of 1991 and 1992, and subsequent independence brought relief and new tensions. Jaan spoke of the understandable pride in things culturally Estonian. A sense of reclamation of language (the Soviets systematically crushed the native language from 1943 and attempted to replace it with Russian – now it could rebuild itself), costume (every region of Estonia has its own costume), art (Jaan, like others, had to fulfil obligations to sculpt or paint images of Stalin), architecture and anything that makes up the varied nuances of a culture.

An example of architecture which gained new focus were the wooden apartments designed and built from the Nineteenth Century up to the 1930s. Jaan had been brought up in one and still lived there with his mother. They were usually on two or three floors with a dozen or so apartments in each building. When I first entered the downstairs lobby I was immediately struck by its beautiful smell. A perfume of seasoned wood, care and lived-in lives. They were constructed entirely of wood and were a fire hazard. This point was utilized by a disaffected militant group who felt that the new independent government was misspending what spare monetary resources it had on restoring these buildings (as heritage) rather than developing the welfare system. And so it had become a common sight to see a newly-torched apartment block becoming a blackened symbol of political protest.

One morning Jaan and I arrived at one such site, still smoking from the previous night's nocturnal gesture. As we stood there one floor collapsed at our feet. The six artists from Britain were given a brick and mortar townhouse, due for demolition, to make our site-specific works in. We had a room each. I spent some time cleaning mine, and several weeks on my hands and knees constructing the vulnerable floor piece 'In Parenthesis – For Jaan Toomik'. Only a few months before I had made my first 'Burnt Wall' in Norwich, and it seemed fitting that the humbleness of the materials and their acts of architectural destruction acted as both counterpoint and metaphor to the silent and censored voices of disenfranchisement and the intangibility and unaccountability of the power bases. The simply struck match is akin to saying 'Hey, listen'.

'Llawr Fforestfach – Reclaimed Parquet' – at the beginning of 1999 I had an invitation to take part in the Belizean biennale that coming August. The curators suggested a floor piece, based on images they had seen of mine ('In Parenthesis', 'Burnt Parquet', 'Parallax') and that perhaps something could be made there.

I set about thinking what to do. A series of coincidences soon occurred. On searching for something completely different at a reclamation yard, I stumbled across stacks of parquet flooring at one end of the warehouse. There were various types of woods. One interested me: mahogany. Mahogany, as well as logwood, was taken from the rainforest in Belize during colonial times.

This particular parquet flooring came from a grand house outside Swansea and had been a floor for about 150 years. I did some research. Complete abolition of slavery in the British Empire occurred in 1833. Belize had a special 'deal' with the government. Until 1838 the slaves in Belize were released from 'bondage' but were 'invited' to work for nothing for forty hours a week, after which they could earn money per hour. They were given a new title 'apprentices'. They were slaves by a new name. Preparation and seasoning of hardwood at that time took a longer period than today. The transport of the material to Northern Europe also took much longer than nowadays, and finally cutting etc. brought this wood I looked at well back to the 1830s. The original trees cut down to make these blocks were cut down by people in the shackles of slavery. "Get Slaves honestly, if you can, And if you cannot get them honestly, Get them."[3]

The reclamation yard is in a suburb of Swansea called Fforestfach. Fforestfach means 'small forest'. I would later title the piece 'Llawr Fforestfach'

meaning 'Small Forest Floor' or 'Floor from Fforestfach' – the subtitle being 'returned parquet'. The poetic potential was too overwhelming to ignore. I quickly wrote a proposal to the Arts Council of Wales for my travel costs and funding to ship the parquet to Belize, which was awarded.

It was arranged. Twenty-eight square yards of the mahogany would be purchased and shipped via Bristol to Belize City. This I felt an important detail of the process – the wood would have been transported by water and more than likely to a port like Bristol. It could have been Cardiff, Liverpool or elsewhere – such ports being the trade entrance of the tainted goods, all stained by the abject abuse of that time.

I arrived in Belize City in August, via Houston and New York, to be greeted by Adrian Barron, co-curator of the Earth Art Park Project in Poustinia. I was taken into town. We sipped cold Belican beer on the half-collapsed verandah of the Arts Factory, in the humid air on the edge of temperamental water. I was over-dressed. The verandah sloped precariously towards water as a result of the previous year's hurricane. I found myself in a volatile place where nature constantly pushed itself into your consciousness. It clung to you through your clothing. A four-and-a-half hour 'charabanc' ride later brought us nearly to the border of Guatemala, to a village called Benque del Carmina. It was nightfall as we walked its streets, searching for a lift to the Park which lay a further five miles beyond. Two kittens in a lane played in a manner as they would back home with a cornered mouse. I'm a sucker for the feline and leaned forward with my hand ready to smooth. My torch focused suddenly on their captive. A tarantula the size of my hand nonchalantly played them off. I was a long way from home.

There was no electricity in the cabin where I stayed, only candles and torches. Hastily I put up my mosquito net, lay on my allotted bed and, tired from the journey, slept. The next night I paid more attention to my surroundings and found two scorpions on the floor. From then on, every night for a month we had the scorpion watch. The lights in the rainforest go out as if by a switch. And when the darkness arrives the jungle erupts with the twitching and voices of a million creatures.

Sitting with the other artists, having our candle-lit and mosquito-coiled supper, the damp air buzzed and hissed with bugs of all description. Every surface became a thoroughfare for creepy-crawlies of emerald greens and electric blues. The walls behind were animated with scores of spiders, each of a size which, back home, would have had me running for cover. Here there was no retreat – though rum helped. It was at once beautiful and terrifying. Out of this world came the wood upon which Europeans dined and danced the nights away, uninterested in the nuances of place and cruelty as they stayed comfortable in their privileges.

The floor, due to take nineteen days to arrive, took much longer. It was held up by the Miami Port Authority on suspicion of being something less innocent than wood returning to Belize, officials incredulous at this 'coals to Newcastle' freight. The thought was that it was a detail within a sophisticated drug cartel. Belize, like other central American countries being a siphon for smuggling.

After two letters from the Belizean Prime Minister, it did eventually arrive

and I relaid the twenty-eight square yards into a corridor form fifty feet by five feet. The original bitumen underneath having melted together the blocks made the job of laying harder. There was a wager between the local Belizeans about how long it would last. Some thought a few months, or weeks, maybe a year or two before either rotting or being eaten by termites. It's still there as I write, but will eventually disappear into the land from whence it came. The process complete. Its true 'reclamation'. The documentation will consist of photographic evidence being taken periodically of its vanishing.

'Blue Funk' – the first *Locws International*[4] event in Swansea in 2000 gave me the opportunity of working with the city's castle. I looked at the castle. I thought about its relationship to the landscape. The landscape being the urban centre. I fail to see the beauty other people see in castles. I can't, and it may be my failing, see beyond what it means and what it meant. Norman castles, such as Swansea's, were buildings of extreme violence and terrorism. They imposed their builders' aggression and will on the indigenous culture. My grandfather always said they should be taken down stone by stone. I thought about the plethora of landscape paintings where a castle is romantically brooding under thunderous grey skies. There's a strong sense that the subject of the castle had become subsumed into a passive object. Just another thing in the landscape. Permission was sought from CADW (responsible for the care of Wales' ancient buildings) for use as art material. Permission was granted so long as the surface was not touched in any way. Any ideas of graffiti or actual demolition (stone by stone) were out of the question.

I wanted to bring back its subject for a period. Or at least bring it out of its backdrop, passive object status. For the preceding couple of years I had been showing Derek Jarman's *Blue* to students at Swansea Institute, and analyzing his notions of 'image' and us as prisoners of it. In the sense that, certainly in terms of video and films, once we see an image, we are hooked to it, which diminishes our scope to visualize and interpret. In Jarman's context, the audio of 'Blue' consists of diary readings and observations of his dying through AIDS. The image is a constant field of blue focusing our senses towards the profound audio. He himself said it was part a tribute to Yves Klein.

In some ways this was evidently in my mind as I thought of changing the castle's presence through light projection. By replacing the 'heritage' floodlights with blue gels and adding more light to its interior, the castle became 'Blue Funk' for the duration of *Locws*. People looked again at the castle.

The postcard to some extent replicates the original object's role by pandering to its potential as collectable heritage trinket. The imposition of it forever camouflaged under summer skies.Looking at a collection of postcards of castles it struck me how profoundly, painfully ridiculous they are. Just imagine for a moment how a castle must have been experienced in its own time.

We pick up a postcard of a castle now and think – I don't know what. What are we supposed to feel? These were impenetrable, intimidating buildings of power. There to create extreme fear and passivity in the subjugated. They were buildings where the indignant and defiant were locked up. Keys thrown away. I look at a postcard and wonder what we are supposed to feel. Castles end up on mantelpieces with regards from sender. The castle has drifted back to its passive

landscape and is misunderstood. It has drifted out of time. Semantics all but dried up.

I take a postcard and score through it with blue biro. I score through it again and again. Horizontally, vertically and diagonally I score. The castle is now veiled through a weave of blue. I take another and do the same. And another. I make a collection. You can still see the castle but it's blued all over.

'Drumming' – it was the text that did it, reading the card referring to Goscombe John's 'Drummer Boy' at the National Museum in Cardiff. It tells of the boy, caught at the moment of celebration as the men go to war. In Goscombe John's words, he shouts "to his comrades, beats a stirring and joyful call to arms, forgetful of all sorrow." It seems an obvious thing now but it struck me in its disturbing juxtaposition of music (drum) and war and in this case a boy and war, and that somehow its undoubtedly skillful rendering makes permanent a monument to this fictionalized relationship. And also somehow through its bronze permanence, solidifying, legitimizing both the fantasy and the shocking implication of its intention – to normalize the act. That through this symbol of youth and music it becomes a grotesque myth.

I remembered images in paintings and films of bands of musicians, drum, flute, bass and cymbals on similar errands, and then of the military bands and marches and their attendant military garb. The uniform too is an important element within this caricature.

Perhaps it forced itself upon me more so in the present climate. We see brutality piled upon brutality. Tit for tat. Fear for fear. How much more killing can we witness?

I'm beating my drum in a dialogue with the bronze, countering the 'drumfire'[5]. I'm taking back for a while the sound of drums for music and peace. Perhaps I drum for sadness, for the fact of the hell of the rut of our fear. I'm taking the beat out of its silence but I shall return it. For the sake of sanity and our madness. For as long as the bronze boy plays his silent drum the more it assures us of our fate (our normality). Take it away and our safety-net of mythology is broken.

The works discussed in these notes are all site-specific. My work is often site-specific. My understanding of this term is that the work should be a response to any or all of the historical, cultural, geographical, political, social, and visual aspects of the location of the work. Site-specificity has become a legitimate way of working for contemporary artists, and it is important because it engages with people from the locale for which the artwork is made and of necessity should accord importance to their experiences.

My work can also be culture-specific. If you extend the notion of site to the culture one belongs to, it does not seem strange to me that an artist would be influenced by her/his social context and perhaps make work informed by issues and debates relevant to that culture. Yet I am often asked why I make work about Wales. My answer is 'Why wouldn't I?' I do not believe an artist can escape their time or place. Although many Young British Artists' work may be seen as ironic and lacking in serious content, does this not reflect the time and place in which they are working? (An affluent London where the only thing taken seriously in

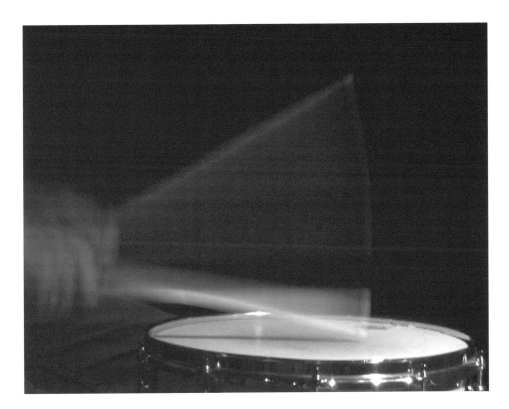

Drumming 2002

art is the money it makes.) In any case, I think the best of them are dealing with issues in their work: gender; homelessness/architectural decay; identity and power. My own work is articulated through my experiences. I do not think they could not be. I do not apologise for it.

Ephemeral, conceptual works are not easy to sell. But art should be more than a commodity. One advantage of site-specific work is that it is often temporary and in public spaces. It cannot be commodified, though of course it can be documented and recorded. Much of my work has been large and ephemeral, even gallery-based work. I am fortunate enough to have a teaching job which provides an income to allow me to make such gestures and frees me from having to sell my work. In fact, apart from small gifts to friends and family, the only bodies that 'own' my work are publicly-funded institutions. I prefer things this way: art becomes more democratic, perhaps more real, away from the auction-houses and private galleries.

I don't know whether it's formal or spiritual, but a major influence on me is music. I've always listened to music. Singing in choirs at school and chapel. Singing *Jungle Book* songs and eventually playing drums in bands in London, playing interesting gigs – Rock Garden, Dingwalls, Marquee etc. – before eventually realizing that I needed to go to art school.

Working my way steadily through music's Twentieth Century, through Sibelius, Shostakovich and Britten (his violin concerto remains a favourite), by default I happened upon early Glass and Reich – particularly *Music for 18 Musicians* – the penny finally dropped. The whole notion of constructing through process and modularity. My work is often made through repetition and factory-like fabrication, using rhythmic manufacturing methods. I try to ensure that the materials with which I work are the most appropriate for the work being made, carrying with them as they do the semantics from their non-art contexts. Sometimes the materials are sufficient as they are, sometimes I manipulate them through chemical and physical processes such as cutting or scorching, sometimes the ready-made speaks for itself with some small intervention. Thus is the manual aspect of my process. The challenge is to connect the concept with the material. My ultimate goal is to distil ideas into their purest visual equivalent. This is my working process.

Tim Davies

Notes

1 Roland Barthes 'From Work to Text' and 'The Death of the Author' in *Image, Music, Text,* London, 1977.

2 Michel Foucault 'What is an author?' in J.V. Harari *Textual Strategies: Perspectives in Post-Structuralist Criticism,* Ithaca, 1979.

3 Caryl Phillips *The Atlantic Sound* p.32, London, 2000.

4 *Locws International* in 2000 and *Locws2* in 2002 were curated and co-ordinated by David Hastie and myself in an effort to provide a platform for artists from Wales to work alongside artists from other countries, making site-specific work in non-gallery contexts in Swansea.

5 David Jones *In Parenthesis* p.124, London, 1963.

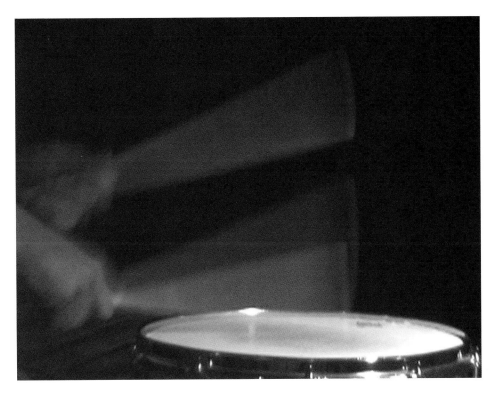

Drumming 2002

David Alston was the Keeper of Art at the National Museums & Galleries of Wales 1994-98, before becoming Galleries Director at The Lowry in Salford. He has contributed to many publications and exhibitions and written on both past and contemporary art in Wales.

Iwan Bala is an internationally acclaimed artist who is also a curator and writer. His work in these various fields, notably through his exhibition and publication *Certain Welsh Artists* (Seren, 1999) has initiated critical debate on contemporary visual art in Wales. He has also worked in the arena of public art with Cywaith Cymru/Artworks Wales.

Born in Cardiff, Susan Daniel-McElroy is Director of Tate St Ives, and is the first female to direct a Tate site. Prior to joining Tate in 2000, from 1997-2000 she was Director of Visual Arts for the Scottish Arts Council and from 1983-1988 and 1988-1999, Director of Ffotogallery, Cardiff and Oriel Mostyn, Llandudno respectively.

Dr Anne Price-Owen is an academic whose primary area of research has been the artist and poet David Jones. Having written extensively on his work, she inaugurated the David Jones Society in 1996. She is also a curator and commentator on contemporary art, and is Senior Lecturer at Swansea Institute where she leads the MA course in Art and Design.

Tim Davies was born in Haverfordwest in 1960, the only son of Zita and Dilwyn Davies. He was brought up in the village of Johnstown but spent most of the summer holidays with his sisters Joy and Moira at his grandfather's in Solva. Davies was very close to his grandfather, 'E.J.', who was Labour chair of the local council in the 1960s and a political activist from the 1950s to 1970s.

Deeply affected by the death of his mother when he was seventeen, Davies moved to London soon afterwards, drifting from job to job and unemployment to unemployment, whilst also pursuing a career in music as a drummer. He eventually found his way to art college, at Ravensbourne in 1985. He studied fine art at Norwich School of Art, where Ana Maria Pacheco became a strong influence and friend, then did an MA in Art & Architecture at Canterbury.

Davies has exhibited widely in the UK and abroad, including shows in Australia, Hong Kong, Belize, Mexico, Ireland, Estonia, Poland and Croatia. He has won several art prizes including the Mostyn Open and National Eisteddfod awards. He has been commissioned to make work for Theatr Y Byd, the Swansea Festival and the BBC, and he is represented in the Art Council Collection at the Hayward Gallery, London.

Co-curator of *Locws International*, a site-specific visual arts event in Swansea, he has also taught art at a school in Bedford, Carmarthenshire College of Technology & Art, Swansea Prison, University of Wales Institute Cardiff and Swansea Institute of Higher Education. He returned to Wales in 1994, and lives in Swansea with his wife Stephanie and son Siôn.

BOOKS

Certain Welsh Artists ed. Iwan Bala (essay by Martin Barlow) Seren, Bridgend 1999

Yr Wyddor, Tim Davies and David Greenslade, Gomer, Llandysul 1998

Ritual, Performance, Media ed. F. Hughes-Freeland (essay by Charlotte A. Davies) Routledge, 1998

Love in Plastic ed. I. Rowlands (essay by Tim Davies) Byd Books 1996

Hello: artists in conversation ed. I. Blazwick (interview with Rosie Gunraj) RCA 1996

Transformation of Appearance (essay by Tim Davies) Tate Gallery/Sainsbury Centre for Visual Arts 1991

CATALOGUES

Roam Coed Hills Catalogue (essay by Tim Davies) 2001

Chora 30 Underwood Street Gallery Catalogue (essay by Sue Hubbard) 2000

Alice Maher + Tim Davies Oriel Mostyn Catalogue (essay by Sue Hubbard) 1998

Continuum Glynn Vivian Catalogue (essay by Martin Barlow) 1997

Standpoints Wrexham Arts Centre Catalogue (essay by Lois Williams) 1995

JOURNALS AND NEWSPAPERS

Planet (article by Osi Rhys Osmond) issue 154, 2002, pp. 41-47

AN Artists Newsletter (article by Tim Davies & Adrian Barron) July 2002, pp. 32-33

Contemporary Visual Arts (article by Hugh Stoddart) issue 26, 1999, pp. 58-59

Circa (article by Alannah Hopkin) issue 88, 1999, pp. 54-55

Contemporary Visual Arts (article by Dawn Fulcher) issue 19, 1998, p.90

AN Artists Newsletter (article by Peter Dormer) October 1995, pp.6-8

Untitled (article by Peeter Linnap) issue 6, 1994, p.3

Art Monthly (article by Paul Usherwood) issue 169, 1993, pp.23-24

The Guardian Guide (article by Simon Grant) 28/12/96-3/1/97 p.9

The Independent on Sunday (article by Tim Hilton) 18/7/93 p.19

PROCESS

COLOUR ILLUSTRATIONS

All photographs by the artist unless otherwise stated.

Tim Davies with son Siôn 2001